Contents

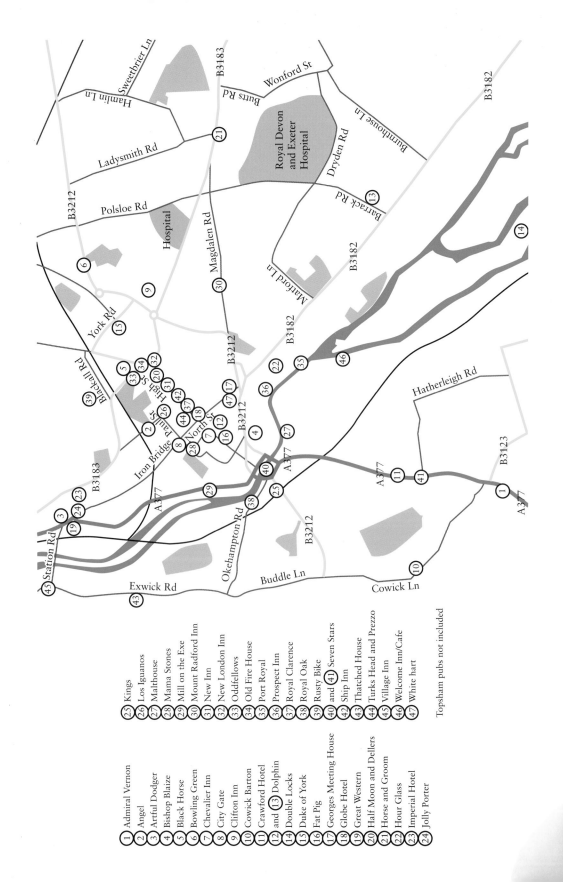

1 Admiral Vernon
2 Angel
3 Artful Dodger
4 Bishop Blaize
5 Black Horse
6 Bowling Green
7 Chevalier Inn
8 City Gate
9 Clifton Inn
10 Cowick Barton
11 Crawford Hotel
12 and 13 Dolphin
14 Double Locks
15 Duke of York
16 Fat Pig
17 Georges Meeting House
18 Globe Hotel
19 Great Western
20 Half Moon and Dellers
21 Horse and Groom
22 Hour Glass
23 Imperial Hotel
24 Jolly Porter

25 Kings
26 Los Iguanos
27 Malthouse
28 Mama Stones
29 Mill on the Exe
30 Mount Radford Inn
31 New Inn
32 New London Inn
33 Oddfellows
34 Old Fire House
35 Port Royal
36 Prospect Inn
37 Royal Clarence
38 Royal Oak
39 Rusty Bike
40 and 41 Seven Stars
42 Ship Inn
43 Thatched House
44 Turks Head and Prezzo
45 Village Inn
46 Welcome Inn/Cafe
47 White hart

Topsham pubs not included

Introduction

In 1880, Robert Dymond published a paper in the Transactions of the Devonshire Association, entitled *The Old Inns and Taverns of Exeter*. This essay covered, often very briefly, many pubs, inns and taverns of Exeter. Since then, there has been no comprehensive book on the pubs of the city. *Exeter Pubs* will hopefully attempt to fill the resulting gap in research, and bring the rich history of Exeter's many pubs up to date.

I have been researching the public houses of Exeter for the past ten years for my website Exeter Memories (www.exetermemories.co.uk), and in doing so, have discovered many interesting stories of Exeter's public houses. The pub section has always proved to be popular, but I know that there are many people without access to the internet who are equally interested in Exeter's public houses. For them, as well as those who already know my website, this book will add much new information. During my time researching Exeter's many pubs, I have discovered hundreds of pubs, inns and taverns from the fourteenth century onwards, as through time pubs open, thrive and then close – a few are still trading after 700 years. The nineteenth century was especially rich for trade and street directories, and from these many new beer houses can be found that are still trading today. Then, the directories named the publican and, using the reports of the licensing committee meetings, a list of publicans can be constructed for each house.

However, a list of names does not make for interesting reading, as it was the lives of the people who frequented the local pub that make them a topic of interest to many. Public houses are, by their very nature, social places, where citizens meet, discuss, argue, celebrate and, often, try to forget. This book attempts to give a history of fifty-four public houses and hotels of Exeter. Some are no longer in existence, overtaken by new developments, loss of trade or the blitz. Some are relatively new, often making use of an existing building and saving it from demolition.

My research has uncovered many stories, some humorous, some tragic. I am especially fond of trivia, as it is often the trivia that gives the best feel for what a time was really like. Some events are unique, such as Exeter opening England's first hotel or the fastest stage coach service to London, commencing from an Exeter inn. People of national and international renown have visited Exeter pubs and hotels, including Thomas Hardy, Charles Dickens and Beatrix Potter. This book will hopefully entertain and inform Exonians on a selection of past and present pubs of their city.

David Cornforth, 3 September 2014

Acknowledgements

I would like to thank the following for their help in writing this book: Julia Sharp, for her encouragement, ideas and reading of the first draft, to catch the obvious errors an author is blind to. The management of the Black Horse and the Cowick Barton, Roger Olver of the Welcome Café (Welcome Inn) and Clive Redfern of the Turf Locks were helpful in my research. Many of the photographs are from the author's archive, but the following individuals were kind enough to allow photographs to be used in the book: Sadru Bhanji (who combed his extensive postcard collection, providing me with several images), Raj Kaushal of the Great Western Hotel, and Catherine Coysh of Kings in Cowick Street. Ryan Goldsmith of Heavitree Brewery allowed me to see their extensive archive of photographs and documents relating to Exeter pubs, for which I am grateful. The historic photograph of the Mount Radford is from Darren Marsh. The introduction of the British Library Newspaper Archive a few years ago has made the task of researchers much easier. Without their website, many of the stories of Exeter's pubs would remain buried deep in the extensive paper archives, probably never to be discovered, and I commend their website (www.britishnewspaperarchive. co.uk) for any would be researchers. And, lastly, I thank Elizabeth Watts of Amberley.

Map illustration by Thomas Bohm, User Design.

Part I

Within the City Wall

CHEVALIER INN, Fore Street

The postwar building on the site of the old Chevalier Inn is now a Wetherspoon's of the same name. The old Chevalier House was two buildings, built from well-seasoned British oak, and although very similar, one dated from the reign of James I and one from just before the Civil War. They had similar projecting oriel windows that jutted over the pavement, the frames supported on carved oak corbels.

A small ceramic equestrian statue was placed on the roof of No. 79, the right-hand house. Said to indicate loyalty to the king, equestrian roof tiles were common across Devon and Cornwall at this time, and at least one other survives at Marazion, Cornwall. Victorian photographic evidence shows the building with no statue, while a 1910 photograph shows the statue. A connection with the Civil War lingered with its alternate name Cavalier House. By 1715, the Fountain Tavern, whose name alludes to its proximity to the Carfoix or public water supply close by, occupied Chevalier House.

In December 1787, a 'For sale' notice referred to the former Fountain Inn; it became the premises of Richard Sercombe, a wine and spirit merchant. From about 1843, John Trehane ran a wine and spirit business from the premises. Trehane was very successful, becoming mayor in 1867. In 1886, the business was sold to Charles Ham for £1,671, requiring Ham to take out a mortgage for £1,500.

In 1923, the last wine and spirit merchant closed and Carr & Quick opened, selling 'The Wine of Devon', a pure apple juice. The building was almost demolished in 1929 when Woolworths, who occupied the adjacent building, tried to acquire the building for a larger store. The city council stepped in, took out a loan and purchased it. It opened as Ye Olde Chevalier Inne in 1930. Disaster struck when this whole area was destroyed in the May 1942 blitz. The post war replacement is hardly an inspiring architectural gem; however, it is still a pub. In 1958, it was known as the Chevalier Tavern and Restaurant, and during the 1970s it became Winston's, No 10's and Churchill's, before it was a favourite student haunt, the Hog's Head.

The New Chevalier Inn

In 2005, it was planned that a new equestrian statue would be placed on the roof of the Hog's Head, after a public subscription organised by local historian Todd Gray. However, in 2009, the ceramic was still languishing in the museum. In June 2009,

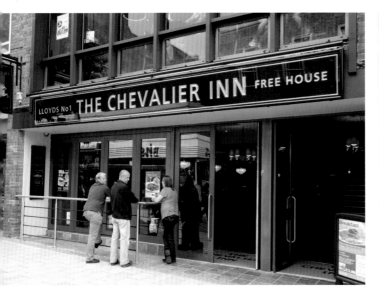

Wetherspoons Chevalier Inn (*left*) and the Chevalier Inn in the 1900s (*right*).

Tim Martin, owner of the J D Wetherspoon pub and restaurant chain, announced that they had taken over the Hog's Head, which would be refurbished. It is now a popular drinking and eating place in the middle of town, under its old, proud name, the Chevalier Inn.

THE CITY GATE HOTEL, Lower North Street

From 1770, the new Crown and Sceptre Inn, by the Northgate, was an important inn at the entrance to the city from North Devon. The Northgate was the first of Exeter's four gates to be removed, along with an earlier inn on the site, in 1769. The removal of the gate allowed an easier, but steep, way up North Street into the city. Stagecoaches from North Devon still had to let their passengers off at the Crown and Sceptre or Barnstaple Inn, so they could ascend North Street with a lightened load. An ostler named Johnny Doe, who was responsible for the 1770 rebuilding, was a well-known character in the city. A saying of his, reused by many locals, ran 'one of Johnny Doe's days – better day than it turned out. The earliest mention in the local papers was in 1778, when the *Flying Post* announced that the landlord was leaving to run the George Inn.

Many inns had their own brew houses, and the Crown and Sceptre was no exception. A sad accident happened to the brewer, Shadrack Kemp, in June 1848. He placed the mashing stick across the vessel, stood on it, and fell into the boiling vat. Calling for help, he managed to crawl out and douse himself with a keeve of cold water. A servant found him shivering with shock, and he was conveyed to hospital, where he later died.

In 1834, the Iron Bridge was constructed, to cross the steep valley below the Crown and Sceptre. The inn was rebuilt to align with the new roadway that was about 20 foot higher. The way over St David's Down and across the flat Iron Bridge enabled horse drawn coaches to enter the city from the north with a full load. The Crown and Sceptre

was an important departure point for Dunn's carriers to many places in North Devon, including Bow and Crediton, departing every Friday at 4 p.m. This service was still in existence in 1915 when the landlord was John Pelling.

The Twentieth Century

James Bell remembers an incident during the Second World War outside the Crown and Sceptre:

> I was passing the Crown and Sceptre Hotel on the Iron Bridge, when a fish lorry lost a box of fish which fell into the road. He did not stop, and some twenty large cod fell out of the box. Housewives passing, rushed out and fought each other. In less than a minute the only thing left was ice, even the box wood disappeared.

It was a lively place in the 1980s, with the cellar bar often full of students listening to local bands. However, decline set in and, in 1991, the Crown and Sceptre closed down. It remained closed until 1997 when it was reopened with a view to refurbishment. A disastrous fire in 1999 badly damaged the roof. A partly renovated Crown and Sceptre reopened in 2000, while the insurance claim was sorted. The new owners invested £1.3 million, changed the name to the City Gate, and reopened the completed premises in 2003.

THE FAT PIG, John Street

Situated on the corner of Smythen and John Street, the Coachmakers' Arms is now the Fat Pig. It is one of only three pubs to remain in the West Quarter out of thirty-one in 1897. On 6 February 1765, the *Flying Post* reported that a fire burnt it down, only for it to be rebuilt. In May 1845, a man was arrested in the Coachmakers' Arms and accused of stealing a basket of beef from a cabin by the master of a ship on the quay. He was discharged for lack of evidence. In January 1858, a further case of theft of a tea caddy containing one and a half sovereigns and thirty shillings in silver from a shelf in the bar, belonging to Mr Holloway the landlord, was tried at the Guildhall. The accused George Cole was found guilty and sentenced to nine months imprisonment.

Plans were submitted in 1904 and approved for alterations to be made to the building. The rear of the building in John Street was originally a Tudor house with overhanging first and second floors that would have made the street appear much narrower than it already is. The overhang was removed, and in the 1920s, the side wall of the pub was extended as a façade across the front of the old building, where the sign protrudes into the street. The rear Tudor building had many rebuilds, but it still follows the layout of the original structure. There is a small yard that gives access to the toilets, and which is a reminder of the many small courtyards that existed behind many Exeter buildings up until the Second World War. The house was sold to the licensee, Austin Harding, in 1965 after the City Brewery was taken over by Whitbread in 1962.

The Coachmakers' closed in 2007, the last surviving traditional public house in this part of the West Quarter. However, it was purchased by brothers Hamish and Rob Lothian and renovated, revealing many of its old Victorian features. Old mattresses

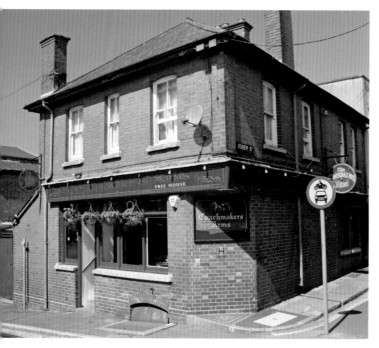
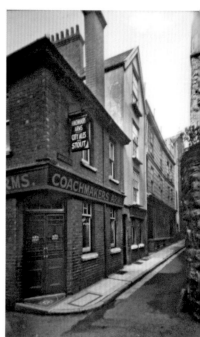

The Fat Pig was previously the Coachmaker's Arms.

and evidence of drug taking were removed and an old sword, coins and a room with original gas lamps and fireplace were revealed. It reopened as the Fat Pig, a gastropub in February 2008.

GEORGE'S MEETING HOUSE, South Street

J D Wetherspoon are particularly noted for taking over redundant buildings and converting them into pub restaurants. They have turned several chapels across the country into eateries, while retaining many of the internal features. George's Meeting House is one such conversion, which has adapted a fine building that had lost its way into a thriving and popular restaurant.

In 1687, the Presbyterians of Exeter occupied a converted house in James Street on the opposite side of South Street, which they named James's Meeting House. When they opened George's Meeting House in 1760, the old meeting house was converted back into a house, to be eventually demolished in the 1960s by the city council. George's Meeting House is a fine example of an eighteenth-century Unitarian chapel. Founded in the coronation year of George III, the building has a striking façade on South Street.

Local Families

The historian, Jenkins, wrote of George's Meeting House, 'it has a large and genteel congregation belonging to it', which sums up the merchant class who worshipped there. An enthusiastic supporter in the early years was Sir John Baring, woollen merchant and banker. Another worthy member of the congregation in the early years of the

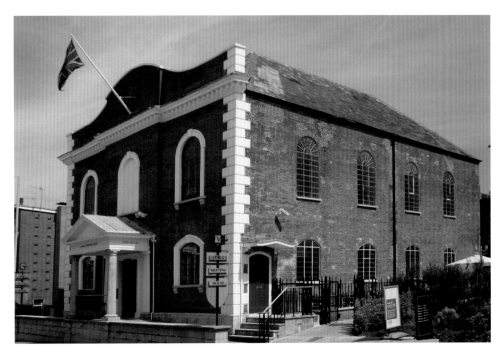

Wetherspoon's George's Meeting House.

nineteenth century was 'Iron Sam' Kingdon, who ran a foundry in Waterbeer Street. He was born in 1779 and was baptised there, to become the first Mayor of Exeter from a dissenter's background. The polymath Sir John Bowring was also intimately involved with the church in the nineteenth century. In 1873, E. B. Stephens, the creator of the Deerstalker in Northenhay Park, produced a marble bust of Sir John for the building, which can now be found in the Devon and Exeter Institution.

The funds to build the new meeting house were raised by the sale of the old house in James Street, while a further £400 was borrowed. The Kennaway family, woollen merchants and later wine importers, also made a substantial donation towards the building work. Many in the congregation subscribed extra funds to the project.

The Building

The building is of two storeys, constructed of local brick of the kind found at Dix's Field and Bedford Circus, with added quoins of Portland stone. The Tuscan style portico is topped with a stone architrave, and a shallow pitched roof. At roof level is a stone parapet over a modillion cornice running over the windows, and a hip roof of slate. When originally constructed, the building was hemmed in by surrounding tenements. Despite this, the sides have four windows on each floor. The interior is a simple rectangular space, with square, fluted, Ionic piers around three sides, supporting a narrow oak panelled gallery and a plain, flat plaster ceiling. The eighteenth-century carved pulpit, designed to allow the resident preacher to be seen, has carved drapery, and was imported from another meeting house on the corner of Palace Street and South Street.

In his memoir, John Bowring wrote that in the vestry was a marble tablet, surrounded by iron rails and covered with flowers of wild convolvulus. It was inscribed 'Mr James Pierce's tomb'. James Pierce was an early eighteenth-century preacher, who had crossed swords with the 'bigoted Church of England clergyman of St Leonard's'. After Pierce died in 1726, the clergyman had refused the tablet to be placed over his grave, in St Leonard's churchyard. The tablet was placed in the Mint, and moved to George's Meeting House in the nineteenth century. In the centre of the church was a large, brass chandelier, suspended on a twisted rod of iron, on which 'SS', the initials of Sarah Stokes, were fashioned in gilded work that could be read both forwards and backwards. On the western gallery, over a late seventeenth-century clock, there is a golden setting sun.

Opposite the clock was a gilded Scythe of Death, a timely reminder to the pious that their time on earth was only too short. There was a small burial ground at the rear of the building. The church went into decline in the nineteenth century due to a series of ministerial crises and a loss of the merchant class to the established church, probably to fulfil their political ambitions.

End of Service

During the twentieth century, the congregation declined and by 1983, the building was disused to be sold in 1987 for an antiques centre. Later, as the Global Village, it was used for a retail furniture and artefacts outlet from around the world. J D Wetherspoon purchased the old church and opened their second pub in Exeter on 16 January 2005. It was the first Wetherspoon's, and also the first pub in Exeter to ban smoking. Their conversion has preserved many of the old meeting house's features and saved a fine building from further dereliction.

GLOBE HOTEL, Cathedral Yard

The morning after the May 1942 Blitz, the Globe Hotel in the corner of Cathedral Yard stood proudly, undamaged, amidst a raging inferno. Twelve hours later, the hotel had been gutted, and Exeter had lost a hotel that had stood for more than 250 years. The building was a four storey Georgian main edifice alongside an older, three storey house that contained a Tudor period oak-panelled room. The hotel stretched from Little Stile, a narrow gate joining South Street to Cathedral Yard, to the corner of St Petroc's Church in Cathedral Yard.

Between 1573 and 1603, the site of the Globe was noted as 'part of the Cathedral cemetery' converted into 'a garden in the tenure of Jno. Ellacott'. It is probable that this garden became the Georgian section of the hotel next to St Petroc's in 1707, when it was 'since converted into a dwelling house or houses'. The Tudor building on the left was home of the Northmore family.

It Becomes the Globe

A baptism record states, '25th October, 1674 of Thomas son of William Fowler, Tapster at ye Globe'. In 1772, a plan of the 'Globe Tavern, Tennements and Buildings' was drawn up that indicated it was granted to William Rigg, maltster. The tavern was a centre for cockfighting in the eighteenth century, ironically, only yards from

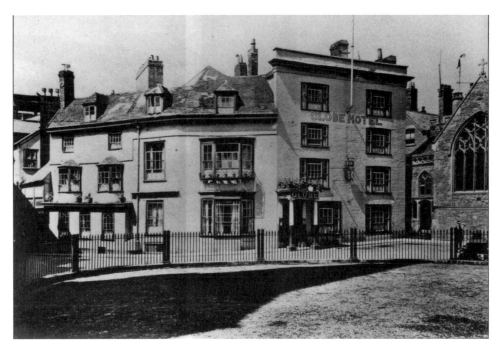

The Globe Hotel in the 1920s.

the Roman garrison cockpit. Local citizens met there before the annual 5 November celebration in Cathedral Yard – an event that the militia were often called out to, to quell the rioting. Its rooms were also used by Britain's first beekeeping association for their meetings between 1797 and 1807. The Globe was important for Freemasonry in Devon when it became the meeting place in 1774 of the Provincial Grand Lodge of Devon Freemasons, founded by Sir Charles Bampfylde who was the Master of the Lodge. Sir John Graves Simcoe, the first Governor General of Canada, was initiated into the Lodge at the Globe Hotel. During the 1830s, it was a frequent meeting place for Tory candidates, a time when votes could be bought for the price of a dinner.

In 1921, the hotel was bought by Mr and Mrs Brand, who eight years later put it on the market for £12,500, but it was withdrawn from sale. The hotel was lost to fire after the bombing of 4 May 1942, when the shops behind on South Street caught fire. It was described as 'damaged by fire' in a report but photographs show that it was completely gutted.

HALF MOON HOTEL, High Street
Originally a coaching inn, dating from around 1680–90, the Half Moon was demolished in 1912 and replaced by the well-remembered, and also lost, Dellers Café. The Half Moon had some splendid decorative plaster ceilings, which may have been by Thomas Lane, who had installed the ceilings in the adjacent New Inn in 1689. When the hotel was demolished, one of the ceilings was removed and put on display in the Royal Albert Memorial Museum.

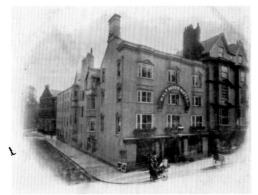
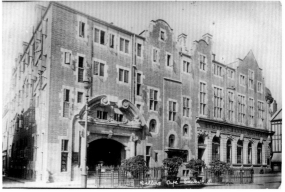

The Half Moon Hotel (*left*) was replaced by Deller's Café (*right*) in 1916.

A sale advert in the *Flying Post* for December 1771 said that Mr John Land had newly occupied the Half Moon and installed 'new built stables & coach houses', which comprised eighteen stalls, coach houses for eight to ten carriages and two hay lofts. The next April, an advert reported that John Hemmings from Bath had taken on the business: 'He also proposes to open a genteel COFFEE-ROOM & hopes if care, attention, and an Endeavour to please can merit the Approbation of the Public, he shall be intitled [sic] to their favours.'

Hemmings encountered problems at his inn when, in 1774, a fire was reported. It was alleged that one of the ostlers had carelessly left a candle over some straw. The fire 'was happily extinguished without doing any considerable damage'.

A Coaching Inn

Before the railway arrived in Exeter, the Defiance coach left for London from the Half Moon. In 1840, they were granted a licence to run a Royal Mail coach via Yeovil and Sherborne that joined the Quicksilver mail train to arrive in London 18 hours later. There was a daily Nautilus service to Torquay, via Dawlish and Teignmouth, leaving at 5 p.m., after the arrival of the London Telegraph. James Cossins remembered the arrival and departure of the coaches from the Half Moon during the first decades of the nineteenth century:

> the Half Moon Hotel ... was kept by Mrs. Medland, afterwards by Mr. Stephens; when several coaches started for and arrived from various parts, the guards enlivening the inhabitants with tunes from their bugles. One was named 'Jack Goodwin,' who was considered a master of this instrument, which now is quite out of date.

Some local stagecoaches survived for a few years after the coming of the railway, as they coincided with the arrival and departures of trains. An advert from the *Torquay and Tor Directory* from April 1846 promoted such a service.

REIN-DEER (Fast Day Coach,) at ¼ before 8 o'clock A. M. through Teignmouth, Dawlish, Starcross, &c., to the Half-Moon Hotel, Exeter, arriving in time for the Quick Train, so as to allow passengers leaving this place in the morning, to arrive the same Day at Bath, Bristol, Cheltenham, Gloucester, Birmingham, and London.

The hotel was popular with local merchants, who would meet in the early part of the nineteenth century to talk business and enjoy a glass of grog and a clay pipe of tobacco. The hotel, like others in the city, was used for auctions, especially of property and estates, and the installation of a billiard table in 1871 encouraged business. Arthur Sullivan, of the operatic fame, first performed the music of *The Mikado* to W. S. Gilbert on the hotel's piano. It is worth listing the staff in 1901 to see the variety of work available in the hotel trade: porter maid 2, nurse 1, staff maid 1, chamber maid 3, house maid 2, kitchen maid 1, bookkeeper 1, bar staff 2, waiters 2, night porter 1, and others 2. The hotel was demolished in the summer of 1912 and replaced by the single-storey Lloyd's Bank on which the famous Deller's Café was built in 1916.

LAS IGUANAS, Queen Street

Episcopal School
The premises of Las Iguanas bar and restaurant in Queen Street, which opened in late 2013, has an interesting history. The solicitors Messrs. Geare and Tozer occupied rooms in the building that up to 1818 would become the house of the headmaster of the new Episcopal School. The entrance courtyard of the school was from the corner courtyard, the school being constructed in Upper Paul Street, behind the present restaurant. The school was a two-storey building with the boys' classrooms on the upper floor. It opened in 1818. By 1823, the accommodation was proving to be inadequate for the growing school and £500 was used from a £5,000 legacy from Mr Worth to enlarge the school for 300 pupils. Through the nineteenth century, social attitudes were changing, and by 1850, girls were being taught arithmetic and to write. The school moved out to a new, purpose-built school on the 21 January 1862.

The Brewery Moves In
When the school site became vacant, Harding and Richards of the St Anne's Well Brewery placed an advert on the 13 December 1862, informing the public that

> they have secured the lease of the extensive premises recently constructed by T. Latimer, Esq., on the site of the late Episcopal Schools, Their removal will take place on the 1st January, on and after which date, Messrs. H. and R. request all communications may be addressed to Queen Street.

The Royal Albert Memorial Museum was built in the years 1865 to 1869, on the opposite side of Little Paul Street, and Queen Street suddenly became the new trendy part of town. The museum retained some existing cellars when it was built, and in 1869 a tunnel was constructed from Harding and Richards own cellars, under Little

Paul Street, to link to the museum cellars. A stone was placed with the inscription 'This tunnel was built on the construction of the Albert Museum 1869 by Harding Richards, Wine Merchants'. The tunnel has since been bricked up, and Harding and Richards reverted to using only the cellars below the shop.

Briefly a Sports Shop

The premises remained as a wine and spirits merchant through a couple of changes of ownership until sometime after 1985, when de Paula Sport occupied the building. The well-known Chumleys Bar opened, and remained a favourite watering hole in Queen Street before the business was renamed the Pitcher and Piano in February 1998.

Roll forward to 12 September 2013 when the Pitcher and Piano closed, after the company received an offer they 'couldn't refuse' from an unnamed company, which turned out to be the Bristol-based Las Iguanas. The business was founded in 1991 and had been expanding for some time, with thirty branches across the country, when it pitched for the premises in Queen Street. After an extensive refurbishment, it was announced that the opening was to be on 14 November 2013. Thus, this fine Victorian building, so long serving Exeter as a wine and spirit shop and later a restaurant, continues in use in Queen Street, hopefully for many more years to come.

MAMA STONE'S, Mary Arches Street

In 2009, it was announced that the closed, former pub and music venue, The Hub in Mary Arches Street, had been taken over by Wendy Joseph, mother of Devon's soul diva Joss Stone. The building was to be refurbished and open as a live music venue, Mama Stone's. The building dating from the 1950s is on the site of a former almshouse and alehouse.

John Davye, a mayor of the city, founded Davye's Almshouses on the site in 1600. By 1810, the almshouses evolved into the London Ale House. In 1837, the landlord was Mr S. Moore, who announced the birth of a daughter. Like many public houses, the London Ale House was used for local inquests; one, in 1850, was for a ninety-year-old lady who was accidentally killed when her clothing caught fire. In 1853, an eleven-week-old illegitimate infant died from convulsions, although two witnesses stated they thought the young mother had given the child something noxious before its death. Mr Samuel Moore who ran the house from before 1837 died at the age of seventy-three in 1861. The licence was transferred to Mr John Strong in October 1861. On his death in 1870, his wife took on the licence. In 1879, the united charities of Flaye, Lethbridge and Davye placed the London Ale House, still in the occupation of Mrs Strong, and four cottages at the rear for sale.

Poisoned Servant

When Mr Banbury was landlord, in 1896, a general servant, Caroline Owen, in his employment was admitted to hospital after suffering from poisoning by laudanum. The woman had consumed the substance, which was meant for toothache, by mistake. Realising her error, she threw the bottle away and ran to a neighbour, who called Dr Moon. Before the doctor arrived, a cab took the girl to the hospital. There is no indication of her fate.

In the same year, the house was up for sale. The rent for the house, which contained a bar, smoke and tap rooms, was £50 per year. Three months later and Captain Banbury, as he was referred to, died aged fifty-two. He was a prominent Conservative. His wife continued to run the house, and her Conservative sympathies emerged when the house was host to the annual dinner of the Exeter Working Men's Conservative Union in 1898. Mrs Banbury retired in 1900 after eighteen years, when she was presented with a purse of money collected by customers of the house. Mr Bradford, formerly of the Victoria Inn, Paris Street was granted the licence, although he was warned by the magistrate that the authorities would keep an eye on him, as he had been previously summoned for allowing drunkenness on his premises.

The New Building
The pub's identity as the London Ale House came to an end after at least 150 years in 1958, when the landlord, Reg Bowden, was relocated to the Spirit Vaults in South Street, and the London Ale House was demolished for road widening. Heavitree Brewery rebuilt the house and Reg Bowden moved back into the rebuilt pub, which was named The Mitre. Fashions come and go, and pub names, once seemingly fixed forever, suddenly change on a whim. The Mitre became The Exchange and then in the millennium, Three Fat Fish, concentrating on music for students from an expanding university. The Three Fat Fish struggled before closing and reopening as the more trendy The Hub. However, it was not long before The Hub closed in early 2009. Wendy Joseph's ownership of the newly named Mama Stone's was a turning point for the pub and music venue. The building was transformed during July, and it was reported that Joss Stone had helped refurbish the place. The opening weekend featured Joss Stone and her band; she still makes occasional appearances, often with guest musicians, such as Jeff Beck in 2012, and Mama Stone's is now a favourite for music in the city.

NEW INN, 25–26 High Street

Became Green and Son, Bobby's (and Debenhams)
In May 1942, the department store Bobby's was destroyed by fire and bombing. In one night, the last of a building that dated back to the fifteenth century was lost to be replaced by a 1950s, brick-built block of shops. A shoe shop and travel agent now occupy the site. The New Inn was arguably the most important inn within the city of Exeter for almost 400 years. It was first mentioned in 1445, when the Dean and Chapter of the Cathedral granted permission to construct a tavern, on land that belonged to the church in the Parish of St Stephen. The inn was often a point of issue between the cathedral and city for its encroachment onto city land. Again in 1447, the inn was mentioned, this time when its own lease was renewed for a tenant by the Dean and Chapter for fifty-six years at a rent of £5.

The Merchants' Hall
Over the years, the inn was remodelled and its rooms adapted for various uses. In 1554, the City resolved to move the woollen market at the Cloth Hall, established

at the Eagle or le Egle opposite the Guildhall, to a hall at the New Inn. In 1555, it was described as 'a commodious hall for all manner of clothe, Lynnen or wollyn, and for all other m'chandises and wch shalbe called the m'chants hall'. The New Inn continued under the stewardship of a succession of innkeepers, some good, some bad, as documented by the city records. After 1612, the New Inne Halle or Merchant Hall was let separately from the New Inn as an exchange for cloth merchants; the merchants rented stalls in the hall to conduct their trade. In 1626, there was an account by Thomas Flay, Receiver of the City, in which the county magistrates are said to have held their sittings at the inn.

Work on the famous Apollo Room, which survived until 1942, was started during the Civil War. Its handsome ceiling dated from 1689, being a prime example of the work of the Devonian Thomas Lane, who was paid five shillings per yard, or a total of £50. It measured 10 metres by 7 metres wide and there were various coats of arms painted on the walls of the room, including the Royal Coat of Arms and the City of Exeter, as well as those of prominent Devon families.

Andrew Brice's *Postmaster* or *Loyal Mercury*, in 1723, printed an advert in relation to untrue rumours of a recent fire at the inn: 'three as much Stable room as belongs to any other Inn House in the city, with handsome accommodation for coaches &c. and above one Hundred Horses'. The stables were at the back of the inn, on the opposite side of Catherine Street.

The Centre of City Life

The New Inn was the centre of public information and entertainment in the city. In the front of the inn was where a new monarch was announced to the public. In 1728, the same year that Gay's *Beggar's Opera* was staged at the Seven Stars Inn, St Thomas, the New Inn staged a performance of *Hamlet*. In 1779, there was published in the *Flying Post* a report of a protest against bull baiting outside the New Inn. In 1765, the *Flying Post* published this advert:

> Advert. A man of cocks will be shown, 30 a side, on Monday 4th March next, & to fight the two following days at the New Inn, Exon, for 4 guineas a battle, and 60 guineas the odd battle, between the Gentlemen of Dorset & Gentlemen of Devon. Russ & Burt. Feeders.

In his *Grand Gazetteer*, Andrew Brice wrote that the Apollo was the only Lodge of the Exeter Freemasons, although this function was soon lost to the Globe Hotel in Cathedral Yard. However, it was appropriate that the Apollo Room was used to lay out the body of Brice when he died in 1773. From the Apollo Room, his body was accompanied by 200 of the fraternity of the Lodge of Exeter Freemasons and several judges to Bartholomew's Yard for interment.

Situated on the High Street, between the Half Moon and St Steven's Bow, a passage way and yard led through to stables on the opposite side of Catherine Street. Over the years, shops were built in front of the inn. The cloth market was moved to St John's Hospital School in 1778, which initiated the slow decline of the hostelry. In the first

years of the nineteenth century, it further suffered from a restricted site and competition from the Bude and New London Inn. The end came in 1833, when it closed and Green and Son opened its drapery shop on the premises. Eventually, Green's were taken over by Bobby's in 1922, who were themselves taken over by Debenhams in 1927.

The Apollo Room was one of Exeter's gems and would have been preserved if it had survived the bombing. A ceiling from the Half Moon, of a similar age and style, was removed in 1912 when it was demolished, and can now be seen in the Royal Albert Museum. So next time you book a holiday or buy some shoes at 25/26 High Street, remember this was the site of the most prestigious New Inn.

THE SHIP INN, Martin's Lane

One of Exeter's most popular public houses for the tourist, the Ship Inn, can be found in Martin's Lane, just off Cathedral Yard. Although the interior is more fake than genuine, the building and much of the structure can be traced back to a row of fifteenth-century shops. Three storeys high, the exterior has a restored overhanging timber front, with a gable roof on one end. Upstairs there are many original timbers, although the whole has been considerably restored. On the front is displayed the following, supposedly written by Sir Francis Drake in 1587: 'Next to my own shippe I do most love that old Shippe in Exon, a tavern in Fyshe Street, as the people call it, or as the clergy will have it, St Martin's Lane.' There is no real evidence that Drake frequented the Ship, and it is to the owner of Mol's Coffee House gallery, Thomas Burnett Worth, that one has to turn to for Drake's association with the tavern. He is responsible for promoting Drake to increase tourism and trade to his gallery.

The Civil War

The Ship can claim to have a connection with the English Civil War, however. The Royalist Captain Benet billeted his troops in the Ship Inn while the city was under siege

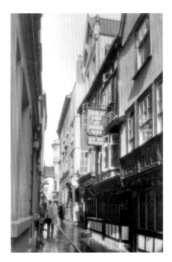 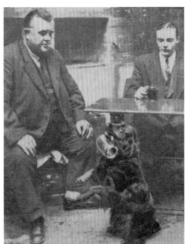 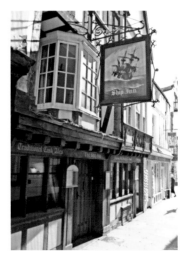

The Ship in the late 1940s (*left*), Sam the bartender (*centre*) and the Ship in 2005 (*right*).

from General Fairfax. Benet wrote, 'I have quartered my men at the Ship in St Martin's Lane, an excellent place with good wine, victual and forage.' Later in 1719, the Ship was threatened by an unruly mob, who tried to burn it down because they thought some clergymen, in alliance with the Whig Government, were being sheltered there. A group of soldiers had to be used to quell the uprising.

The Twentieth Century
In August 1920, the wife of the landlord had the distinction of being the first Exeter lady to loop-the-loop in an aircraft. The plane took off from the Pinhoe Aerodrome and circled the city three times before performing the loop-the-loop at an altitude of 3,000 feet.

Sam the Spaniel
The landlord Reg Pring owned a black spaniel named Sam in November 1939. The dog would greet customers at the door, fetch glasses and allegedly take glasses of beer and pasties to customers seated at the tables. Once the order was safely delivered, the customer was expected to pay Sam with the correct coinage, which he would flip into his mouth and then drop into a tin behind the bar. Sam's skill was used to raise money for the Spitfire Fund, War Weapons Week, Salute the Soldiers and other worthy causes. His record intake in one week was £23, which he delivered to the mayor's parlour. He was said to be fond of beer, which along with the dog biscuits, was sufficient payment for the canine bartender.

Sam had many GI friends, although one sour American thought it funny to heat a penny in the fire. The unsuspecting Sam flipped it into his mouth, only to yelp and spit it out, suffering burns to his tongue that took several days to heal. The American was promptly barred. When Sam died, the local paper ran an obituary, which included, 'Sam is dead ... Sam, the pedigree black cocker spaniel, darling of mine host Reg Pring and of mayors, civic dignitaries, Tommy, Jack, G.I. Joe and the Land Girl.' Sam's seven-month-old son, Punch, was said to be at 'the journeyman stage of carrying letters and newspapers for his master. Punch also likes his sup of ale.'

In 1964, the two lower bars were knocked into one and the pub started serving meals in the restaurant above. Later, in 1994, the premises were refurbished, which bizarrely led to the Shipski in Kaliningrad (if that is what it was called). A Russian visitor paid £2,700 for all the fittings and fixtures to fit out and open the first English pub in his home city. Who needs Drake with a history like that?

TURKS HEAD, High Street
The earliest reference to the site of the Turks Head was in 1289, when the city authorities granted to the owners of the land the right to lean a beam against the wall of the Guildhall for the sum of one penny per year. By the time of Charles II, inflation meant that a penny was not sufficient and the rent was increased to two pennies per year, which is the amount payable today.

In 1569, the Turks Head Tavern was put up for sale and sold for four score pounds (£80), while the yearly rental for the site was assessed at £4 10*s*, with a further sum

Above: The Dickens Bar in the Turks Head is shown above.

Right: Turks Head is now the restaurant Prezzo.

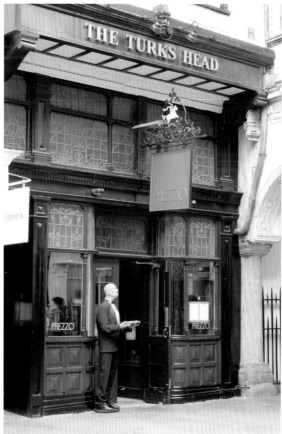

of 10*s* to be paid to Her Sovereign Lady Queen Elizabeth. Documents confirming the above are held by Exeter Museum. The inn has a very narrow frontage (13 foot), but is 130 foot deep and five storeys high. When it was refurbished in the twentieth century, five medieval fireplaces were found.

Two beer thieves were caught in 1828 when James Jackson, a brewer's assistant at the Turks Head, was seen bringing a bucket of beer to the rear entrance for William Garland to fill a jar, and disappear down Pancras Lane. This was repeated several times through the early hours. A hidden policeman had observed the thieves, and found 7 ½ gallons of beer in Garland's house. By the 1880s, a taproom was opened at the rear in Waterbeer Street.

The Name

There are several possibilities to the origin of the name. It is said that the name of the Turks Head refers to a Turkish prisoner, who was held here when the inn was used as a prison. He met his end by the executioner's axe. An alternative origin was suggested by Richard Pring of the City Brewery, who wrote that there was a jousting ground at the rear of the establishment where the head of a Saracen was used as a target. This seems an unlikely story. Elsewhere, the name probably goes back as far as the Crusades. It originally referred to members of the Tartars who settled in Turkey. Turks Head is also used to refer to a particular knot that is similar in shape to a turban, again indicating its link with the Crusades. The scourge of the sixteenth and seventeenth centuries, the Pirates of Algiers are said to have kidnapped into slavery people living on the coast of Cornwall, and maybe they were connected with Turks heads.

A Dickens of a Place

Charles Dickens used to sit in what is known as Dicken's Corner. He observed the Exeter character, who became Fat Boy in *Pickwick Papers*, supping his ale. Dickens was a frequent visitor to Exeter and he rented Mile End Cottage in Alphington for his parents. Although the legend 'Turk's Head' still appears over the front of the building, the premises now belong to Prezzo, a family orientated restaurant on three floors. Little of the original hostelry remains apart from the façade.

THE WHITE HART HOTEL

The White Hart was the home of William Wynard, recorder of Exeter between 1418 and 1442. Exmouth pirate and benefactor Wynard built Wynard's Hospital and Chapel in 1430, for a priest and twelve infirm or poor men. He endowed his home, along with other property, in 1436 to his hospital and chapel, as a source of funds. His house was initially named the Blue Boar Inn, before it became the White Hart. Located at the bottom of South Street, just inside the city wall and near the South Gate, the White Hart was well placed to stable pack animals and horses along with many wagons and carriages.

The Cockatrice

Richard Izacke documented an accident at the White Hart in 1649, the year of Charles

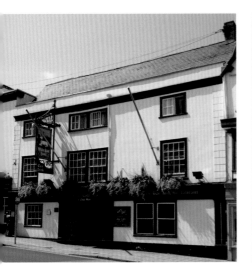
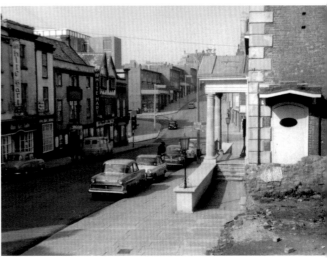

The White Hart is one of Exeter's oldest inns. George's Meeting House (*right*) is opposite the White Hart.

I's execution. The inn had a well that had long been neglected by the inn's owner, Roger Cheek. He employed Paul Penrose to descend the well for repairs; at the bottom, Penrose suddenly fell dead, suffocated by an uncommon stench. A second workman, William Johnson, was sent down to investigate, when he too fell dead. A friend of the men, keen to help, also descended and almost died, but was pulled back up. He rolled around in agony, to be revived with water and oil. On recovering, he described a strong smell that hindered his breathing. Onlookers claimed it was a cockatrice (a legendary creature, part lizard, part rooster) that caused the deaths, but the more rational agreed that it was the damp or some sort of marsh gas. To substantiate the story, although there is a discrepancy in the names, the burial records of St Sidwell's record that William Will was buried on 28 June 1649, having died of a damp of the well at the sign of the White Hart in South Gate Street.

In the eighteenth and early nineteenth centuries, the proximity of the White Hart to the old Southgate ensured a busy trade with carriers throughout Devon, offering services to Axminster, Beaminster, Beer, Seaton and Ilminster among others. Competition was intense, with the nearby Mermaid and Dolphin Inns, and Russell's Carriers, based just up South Street all vying for business.

Cholera and Elections

In 1832, the inns and hotels of the city experienced a drop in guests as cholera swept the city. The West Quarter, of which the White Hart was on the edge, had the highest number of deaths. By 15 September, the *Exeter and Plymouth Gazette* noted that the epidemic was abating and that guests were returning, including a number of commercial gentlemen to Wethey's White Hart. In 1835, the independent candidate, E. Divett MP, used the hotel as a campaign base for election to Parliament.

The very limited franchise at the time led to the buying of votes, and the dinner for eighty held at the White Hart was probably just part of the price paid to be re-elected.

Cycling Club

In common with many other inns and taverns in the city, up to the First War, the White Hart was host to many annual dinners for clubs and societies. Some odd dinners by our standards were held at the hotel, including this in May 1906: 'The annual rook pie lunch took place at Mr. Wethey's White Hart Hotel, South-street, an excellent repast being thoroughly enjoyed by a large attendance.'

The Exeter Touring Cyclists' Club made the hotel their official club headquarters in February 1912. After the Great War, membership had fallen dramatically, with many not returning from the trenches, while the popularity of the motorcar pointed to the future. In April 1921, the club was formally wound up at the White Hart and £5 10s 6d donated to the Royal Devon and Exeter Hospital. The licence for the White Hart was held by the Wethey family for over 200 years, when in 1937 it was transferred out of the family to Joseph Rowe Brooking.

The Building

Although the history of the White Hart can be traced back to the early fifteenth century, the façade presents a three-storey, late Georgian exterior, with rusticated quoins, the whole of which is painted white. The first floor has sash windows, while there is a simple cornice over the parapet, with a pitched, slate roof behind. The front door is nineteenth century; it leads into a sloping, cobbled and flagged passageway, which opens into a small, enclosed courtyard. Internally, the building is thought to be mostly sixteenth century, although much of the woodwork, including a Gothic glazed door leading to a staircase, is of late eighteenth and early nineteenth-century origin. To the rear, where the old yard would have stood, there are various extensions and a modern hotel block fronting Coombe Street.

The modern hotel has fifty-five ensuite bedrooms, of which fifteen are situated in the historic front of the building. It has welcomed such luminaries as the exciting *Monty Python's Flying Circus* team when they were filming in Exeter, and Steve 'Interesting' Davis, the snooker player.

Part II

Greater Exeter

THE ANGEL, Queen Street

It was in 1869 that the Victoria Hall was built in Queen Street to provide a 2,000-seat space for conventions, exhibitions and concerts. The hall was situated to the rear and side of a vacant plot of land that fronted Queen Street. While the construction of the hall took place, Mr Pinn, a builder, commenced construction of two houses on the plot of land. He became embroiled with the planning committee for building a chimney wall at the rear of the property that was only one brick thick, thinking that the wall of the adjacent Victoria Hall would be sufficient to prevent a fire spreading. This was in the right hand of the pair of houses that would become The Angel.

In April 1877, William Norton, a cook and confectioner, placed an advert in the *Flying Post* informing the public that he was expanding his existing business and opening the Victoria Restaurant at No. 32 Queen Street, this being one of Mr Pinn's houses. Norton offered cold joints, tongues and seasoned pies, along with wine and Guinness, breakfasts, luncheons, dinners and teas. The close proximity to both the Victoria Hall and Queen Street Station ensured the restaurant prospered.

The premises were also used, as was common in the nineteenth century, for auctions, and in April 1881, a sale was held at the restaurant of property in St Sidwell's and St Mary Major. The next August, the business had become the Victoria Restaurant and Hotel for 'excursionists and tourists and strangers visiting Exeter'. William Norton died, and his widow Ann continued to run the business. In July 1898, she died and Miss Bunning, the former manageress of the Royal Clarence Hotel, took on the business.

The Victoria Hall Burns Down

The Victoria Hall was devastated by a massive fire in October 1919. The buildings shared a rear and side wall, causing some alarm, as flames leapt from the roof of the hall at the rear of the hotel. This was ironically the same wall that had caused so much trouble with the planners, due to the fire risk from the chimney. The contents of the hotel, including wines and spirits, were removed to the Rougemont Gardens opposite, now the front façade of Central Station. The firefighters managed to contain the flames, and both the Victoria and Rougemont Hotels were saved.

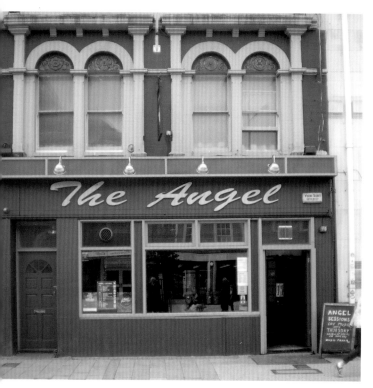
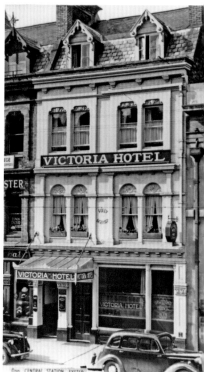

The Angel is opposite central station. It was originally the Victoria Hotel.

The Brewery

The Victoria was owned by Brutton Mitchell Toms, a Yeovil brewery that existed between 1937 and 1960. Situated directly opposite Central Station, travellers from further up the line, who were familiar with Brutton's beers, could cure their thirst with beers they knew, while waiting for a train or recovering from a journey. It was the only pub in Exeter owned by Brutton, Mitchell and Toms. The practice was common for foreign breweries to set up near railway stations, and thus capture their usual clientele when travelling. Brutton, Mitchell and Toms was taken over by Charringtons, who merged with Bass to become Bass Charrington. The Bass portfolio of public houses, including the old Victoria Hotel, was purchased by Punch Taverns in 1997 and it is still part of the group.

During the early 1980s, as the New Victoria, it ran a popular weekly disco, and was noted for its biker clientele. From 1985, it became Garbo's, then from 1989 the Pink Pelican, and by 1991, it was known as Envi. While it was Garbo's, local group Rat Patrol, who had an enthusiastic following, played several gigs there. Now, The Angel is considered to be an elegant, comfortable venue with a mixed custom. It is popular for an early drink for those who arrive at Central Station before a night out in Exeter. It also has a loyal local following, who enjoy the live and open mic music.

ARTFUL DODGER, Cowley Bridge Road

Situated opposite St David's Station in Red Cow Village, the new Artful Dodger student flats were previously the site of a building dating from 1810. Lot one of six lots in Red Cow Village would become the John Bull and later, the Artful Dodger. The lot was described as, 'The first and second new-built Houses on the right hand from Howell's-lane, with the gardens behind and other conveniences.'

The Landlords

In October 1858, John Roberts placed an advert announcing the opening of the John Bull Inn. The second hostelry to open close to St David's station since it opened in 1844, and the third in the area, he offered the travelling public hot and cold refreshments, along with well-aired beds. Roberts continued to place adverts on a regular basis until June 1861. The railway enabled reps and agents to reach new markets, and the John Bull offered them a place to stay while they pursued their business interest in Exeter. An advert in 1874 from the agent John Greenslade, who was staying at the John Bull, was for local families to apply to work in the cotton mills of Lancashire. By this time, Exeter's own woollen industry had died and the city was a good place to recruit redundant workers. In October 1875, the John Bull 'suffered seriously from a rush of water, which made its way down from the field above'. The Cowley Bridge Road was impassable and flooding was widespread. By this time, the landlord was James Thomas Cobley. The licence was transferred to Albert Edwin Cox in 1884, who retained it until December 1884 when it was transferred to Thomas Edward Searle. In the 1889 *Kelly's Directory*, James Searle was listed as a beer retailer. By 1906, Mrs Mary Anne Searle, his widow, was the landlady of the house. She remained there until 1916. In 1918, Samuel Pinnock was the licensee.

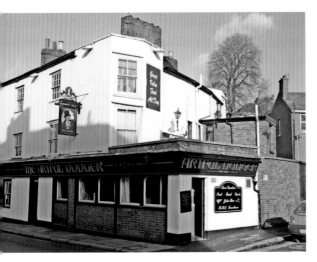
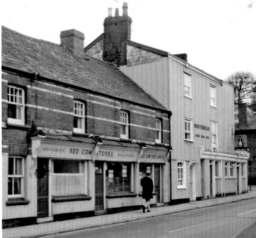

The Artful Dodger (*left*) and when it was the John Bull (*right*).

The Name Change

Roll forward seventy years and two world wars. In 1980, the John Bull was refurbished by the brewery and reopened with the name Artful Dodger. The Grade II listed building had £150,000 spent on it, enlarging and improving the premises. The opening night was on a Dickens theme, with customers and staff dressed in Victorian costumes based on characters from Dickens' novels.

In March 2009, Teresa Claridge, who had run the Artful Dodger since 2004, and her father Bryan Claridge turned it into Exeter's first cider bar. It was short lived and closed at the end of the year. In December 2009, the Artful Dodger was refurbished again and renamed Seamus O'Donnells, in yet another attempt to open an Irish themed pub in the city. In June 2010, a second-floor flat above the pub was severely damaged by fire, delivering another blow to one of Exeter's, by now, struggling public houses. The fire and new name did little for the fortunes of the house, and in a time of austerity, it did not remain trading. In January 2011, it was announced that plans were in place to demolish the building and replace it with student flats. The development went ahead, and a student block now stands on the site of the old public house. The accommodation has five- or six-bed apartments over three floors; each bedroom has en-suite facilities in the form of a shower pod.

THE BISHOP BLAIZE, Commercial Road

It would seem appropriate that a public house situated at the heart of the area that was Exeter's woollen industry should be named after Bishop Blaize, the patron saint of clothworkers. An Armenian, the bishop was persecuted for heresy against the prevalent worship of idols, scourged with iron combs and beheaded in AD 298. The sign of the hostelry shows the bishop holding a wool comb, the symbol of his martyrdom. Situated in the area known as Shilhay, within yards of Exeter's first documented mill, it is thought that the house can be traced back to 1327 and is probably the first public house to be built outside the city walls.

The present building is a pair of terraced cottages with the higher leat running to the rear, which powers the adjacent Cricklepit Mill. The main building and block at the rear date from the late seventeenth and mid-eighteenth century. There are some interior beams from the late seventeenth century. Situated next to the rack fields, where the serge was hung after fulling, the building was used in medieval times as a meeting place by fullers and mill owners. This function moved to Tuckers Hall in 1471. The unfenced lower leat ran across the front of the building, leading to a disproportionate number of drownings, especially of children, who lived in the crowded tenements in the area. The coroner's court met many times in the Bishop Blaize to pass a verdict of accidental death on a drowning. In 1834, the Humane Society reported of the danger, but its poor funding prevented the menace being dealt with. Customers of the pub had to cross a small bridge to reach the entrance, and no doubt, many fell in the leat after a drinking session. Drownings in the leat by the Bishop Blaize were still being reported through the 1930s, and it was not until the 1970s that the leat was filled in. Patrons who choose to sup their pint at the front can sit on a bench on the former course of the leat.

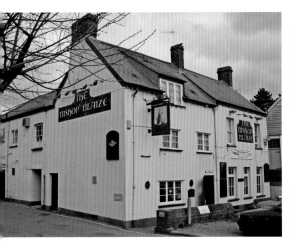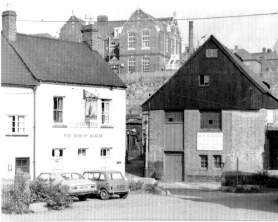

The Bishop Blaize around 2005 (*left*) and in the 1970s alongside Cricklepit Mill (*right*).

A Bad Reputation

As Shilhay became industrialised during the nineteenth century, the Bishop Blaize gained a bit of a reputation. In 1849, when three police officers approached the house one Sunday, two lads out front shouted through the open door, 'peelers'. The officers found the bar, parlour and tradesmen's room empty. They then proceeded to the locked cellar below the brewhouse. They found a key and opened the door, to discover twenty-one people sitting on the floor, smoking their pipes, along with some hidden cups of beer. James Clarke, the landlord, was fined £2 for serving beer on a Sunday during divine service. John Snow, the occupier in 1859, was also fined £2 for serving beer on a Sunday. Ironically, Snow was an overseer and churchwarden of the parish of St Edmunds. Another landlord, William Ley, was fined for the same offence in 1864. Not only did the house have a reputation for illegal drinking, but there were also many cases of drunkenness and assault before the court at the Guildhall, which originated at the Bishop Blaize. In 1884, William Henry Skinner had his application for renewal of his licence refused by the Licensing Justices for the City of Exeter. He appealed through the courts on the basis that evidence given against him in the original application was not on oath. Eventually, a year after the original case at the Crown Court, he won his appeal and regained his licence. The many convictions of landlords of the house did not prevent the local Liberals using the premises for their meetings.

During the First World War, the licensee Mr Harry Pullman had trouble renewing his licence due to allegations that he allowed the selling of stolen military clothing on his premises. A soldier had been convicted of the theft of Army shirts and selling them on in the Bishop Blaize - an offence for which he was sent to prison. Pullman was accused of knowing of the sales in his bar. He claimed that the offence took place behind a screen and, as he was working single-handed behind the bar, he could not have known of it. Although the magistrate had his suspicions, the licence was renewed. In 1917, Pullman was served notice by the brewery after seven years running the house, following his being convicted of serving a wounded soldier with alcohol (brandy), contrary to the law. Exeter

had five VAD hospitals in the city, and all publicans in the city had been warned not to serve wounded soldiers, who wore a special uniform, to indicate their status.

Nosey Parkers and Back

For some reason, after trading for hundreds of years as the Bishop Blaize Inn, the name was changed to Nosey Parkers during the 1980s. Tradition prevailed, and the old name was reinstated in 1988. The modern pub has a strong customer base and in 1990, had its own dragon boat team in the national championships in Cardiff. In 2010, they had a dragon boat team named the Slow Boat to China competing in the Dragon Boat Challenge for the Dream-a-Way charity. They currently have a darts team in the Heavitree Brewery League. With the development of the quay as a leisure area, the Bishop Blaize has changed its customer base from the mill and quay workers of old to customers who are visiting the many historic places in the area, and is going from strength to strength at a difficult time for public houses in the twenty-first century.

THE BLACK HORSE INN, Longbrook Street

The much favoured haunt of the university student fraternity, the Black Horse Inn is the oldest public house in Longbrook Street. It was established in the early eighteenth century as a coaching inn on the main route to Tiverton. Between 1780 and 1787, the licence for the premises was held by Spurrier Flashman, who had been declared bankrupt as a farrier in 1778. In 1788, the inn was burnt down and had to be rebuilt.

Buckets of Beer

In 1804, Private Evans was committed to the Southgate Prison for the offence of stealing beer from William Browne of the Black Horse. Several hogsheads of beer went missing over a period of several months. Evans, along with six accomplices, carried the beer away in buckets after lifting a door off its hinges. Evans was badly injured during his capture; his accomplices were later apprehended, but released through lack of evidence. The lease of the house was for sale in September 1806, for a rent of 10s. The inn was still in the occupancy of William Browne, who had another two years to run. The winning bid would gain the rent from Browne, and gain full possession after two years to allow Browne to continue, or find a new tenant. The Black Horse became an early City Brewery house in 1816 in the occupation of William Collins. James Taylor was the landlord from 1824, when he apprehended two horse thieves. In 1830, a public apology was printed in the *Flying Post* by William Broomfield and William Piper for entering the premises after hours and assaulting Taylor.

Paul Collings

From 1835, the licence was held by Paul Collings and his family. Born around 1798 in Spain, he became an officers' servant in the Wellington's Army. He fought in the Peninsular War and accompanied an officer at the Battle of Waterloo. Collings became head coachman at the New London Inn, where he gained a high reputation working with horses. He moved on to be innkeeper of the Black Horse. In 1836, he was presented with a floral jug as 'a token of respect to Mr. Paul Collings for the invention of the self

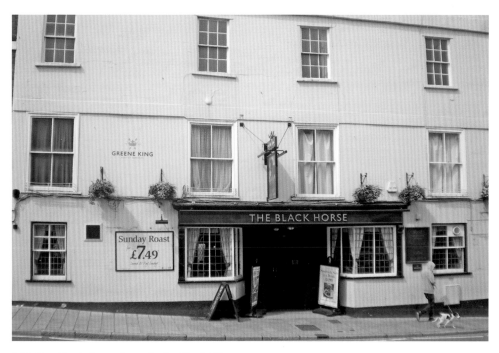

J. K. Rowling's favourite pub, the Black Horse.

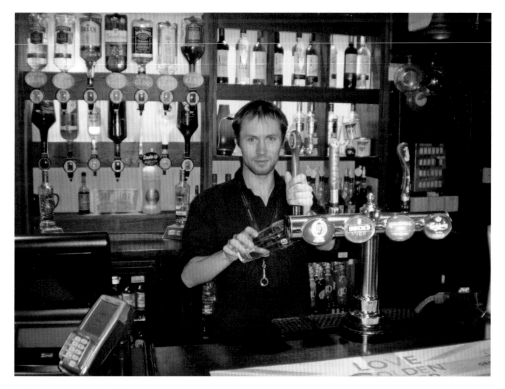

Pulling a pint at the Black Horse.

acting drag, by me who has found it, by experience to be of the greatest utility 1836'. This was a patented braking system for coaches and wagons descending hills. Ironically and tragically, Collings' five-year-old son was killed outside the Black Horse in 1843, when he was knocked over by a coal cart while crossing Longbrook Street. The inquest was reported in the *Flying Post* with the verdict of 'accidental death'. In 1848, Paul Collings witnessed the launch of a balloon flight in Exeter from the grounds of the Castle; he followed the balloon with a carriage, reached the landing point and brought the aeronauts back to Exeter before it became dark. His son, Paul Collings Junior took over the Black Horse until his own death in 1891, and then Mrs S. Collings ran it until 1900. In all, the Collings family ran the Black Horse for sixty-five years.

Exeter Tramways

Paul Collings Jnr experimented with an omnibus service from the suburbs of the city to the centre, but it wasn't until 1880 that the idea of horse-drawn trams was considered. Collings was instrumental in a meeting at the Black Horse Inn on 15 November 1881 to form the Exeter Tramways Co. Ltd. The promoters, Bidder, Buckland and Moore, met several local shareholders to agree plans to build and run a service. Six months later, the trams were delivered to the Black Horse and were put into service on the 6 April. The Black Horse's yard stretched back to New North Road, and it was this frontage that was used for the tram shed and stables for the new enterprise. There is still tram track in the rear of the pub's yard, leading towards the site of the tram shed.

During the Second World War, the Black Horse was subjected to rationing rules, which the manageress broke in October 1942 when she was fined £6 10s for five summonses for breach of rationing. She had purchased 12 lb of bacon when entitled to only 10, and failed to invalidate the ration books of guests. Many of the guests in the twentieth century were actors from the Theatre Royal, until the theatre closed in 1962. The Black Horse is a popular pub for students, especially since it was revealed that the Harry Potter author J. K. Rowling frequented the house when studying at the university. The inn was an inspiration for one of the locations in the books. The pub offers live music, televised sport, an extensive menu, and a lot of hidden history.

BOWLING GREEN, Blackboy Road

The Bowling Green is a popular public house that has served locals for many years, and, more lately, the many students who live in the area. It is located in Blackboy Road, which was also known as the Bath Road, as it was on the main route out of Exeter for stagecoaches heading to Bath. The house dates back to an active rope maker's, which was established in the late eighteenth century.

Rope Making to Bankruptcy

The earliest listing as a rope maker's on the site was in 1791, when it was run by James Hill, who originated from Sandford, Devon. His son James (2) was baptised in 1776, in St Sidwell's church, so it is probable his father was already a rope maker. James (2) married Maria Woof, a woman from St Sidwell, in 1808. James (2) was arrested in

1819 for debt, and spent two years in prison. In 1822, he was declared bankrupt, and the *Flying Post* published his petition to be allowed to continue his business, stating,

To the AFFLUENT & HUMANE
THE humble PETITION of JAMES HILL, late Twine Spinner, in the parish of St Sidwell, (where he now resides) most respectfully begs permission to state, that, on the 6th of October 1819, he was arrested for a debt which he had made himself responsible for by putting his name to two bills, dated 7th Feb. 1815, amounting to £95. 18s. 10d. no part of which he ever had the use of; but a security was lodged for him which was kept by the parties, and he remained in prison nearly two years and half, having been liberated on the 25th of last month, under the Insolvent Act; and during his confinement labouring under an acute disease, which still Continues to afflict him.
JAMES HILL. Dated St Sidwell's, Exeter, 22d April, 1822.

He was supported by fifteen signatories, while twenty-two individuals had subscribed money to support the family. His wife Maria ran the rope maker's after the bankruptcy, and in 1830, she purchased the property next door (No. 30 Black Boy Road), which was described as suitable for a brickworks. His daughter Elizabeth married Alfred James Donoghue in 1859, and lived briefly at her father's. Donoghue had been a soldier with the 8th Hussars, and was one of the trumpeters who sounded the advance for the infamous Charge of the Light Brigade at Balaclava, Crimea.

A plan for the St Sidwell's feoffee shows the land for the rope maker's as a T shape. The base of the T was the frontage on the road, and the long crossed section at the rear was the ropewalk, where the strands that make up the rope were laid, and twisted into rope. It is probable that the ropewalk was contained in a long timber shed. Maria's son James Willcocks Hill (3) took over, and by 1850, it was listed as running a beer house. James Hill carried on the trade as a 'Ropemaker and Beer House' until at least 1871. It was common for blacksmiths, rope makers and others to open a beer house on their premises, to provide for their workers and supplement the family income. This dual use continued and the beer house was formally named the Ropemakers' Arms by 1881. James (3) died in 1877 at the age of sixty-eight, leaving his son James Willcocks Hill (4) to continue the business. In 1881, Susanna Brown, the landlady running the house, gave evidence in a case of obstruction of the Blackboy Road, outside the Ropemakers', by an open air Temperance Mission. She claimed that people could easily pass the impromptu meeting, and the organisers were charged with obstruction. In June 1898, by order of the mortgagee, the Ropemakers' Arms was for auction, with Mr James Wilcocks Hill in possession. Two months later, and 150 lots of household goods were auctioned off. Thus, the last of a long line of the Hill family vacated the premises, after more than 100 years as rope makers and publicans.

End of an Era
In 1900, the new owner rebuilt the premises, although according to the report, the changes did not improve the facilities for drinkers. In 1902, the licence was transferred from Mr C. Morgan to Mr W. C. Chamber, then in 1908 from Chambers to Mr J.

Whensley, who died in 1927 when his widow inherited the licence. The former Exeter City footballer, Mr Charles Miller, was granted the licence in January 1937 from Mr S. Field. It was renamed the Bowling Green in December 1987, due to its proximity to the Exeter Bowling Club green opposite, rather than any association with Sir Francis Drake. The pub sign shows Drake playing his famous game of bowls, before he embarked to fight the Spanish in the Armada on his ship. The house has a beer garden live music, a quiz night and pool table – everything, in fact, to pull in the locals for a good night out.

CLIFTON INN, Newtown

The earliest reference in the *Flying Post* to the Clifton Inn was in 1854, when it opened as a beer house. The Newtown area was a fast developing suburb, and the Clifton Inn was the first to fill the needs of the drinking fraternity in the area. In April 1854, Mr William Beedell, the first landlord, was charged with permitting a disorderly house. PC Plan found several people drinking and making a noise between 11 and 12 p.m. The landlord stated he had been running the house for just six weeks, and the night in question was his opening supper. The case was dismissed, with the defendant paying expenses. By the September of the next year, Beedell was summoned by a neighbour for allowing cards and bagatelle to be played in his house for money. The complainant stated that he brought the charge against Beedell because he had allowed the complainant's apprentices to gamble at the house. Beedell was found guilty and fined 10*s* plus expenses. In October 1861, the troublesome Beedell was again charged with using offensive language to a tenant in a house he rented. He was accused of calling the defendant a 'thundering rogue'. The case was dismissed. A year later and Beedell was accused of opening on a Sunday morning; PC Trapnell had found six men in an office, off the bar drinking around a fire at 11 a.m. He was found guilty and fined 10*s*. By 1863, the landlord was Mr Thomas Beedell, his son. The licence was transferred from Thomas to Mr W. Stabback in January 1869. However, Mr Stabback did not stay long, for in March 1871, a 'To let' notice appeared in the *Western Times*, as the present occupier had moved on to another house. The house was used for the occasional sale, like many other public houses of the time. In August 1892, an advert appeared in the *Flying Post* for a sale at the Clifton Inn of household furniture, linen, blankets and effects, while other sales in the premises were for property in the area. Newtown was a fast expanding suburb of the city, and local speculative builders would auction their new build at the Clifton. There were also the occasional inquests held at the inn, when there was a death within a short distance of the house.

The Forced Transfer

There was a forced transfer of the licence from Mr W. B. Short in April 1893. It would appear that the magistrate thought that Mr Short would not be in a position to run the house, as he was also a member of the Exeter Fire Brigade. Mr Short argued that his wife would run the inn on those few occasions when he was called out to a fire. He wanted to retain the licence and stated he 'would sooner give up the Fire Brigade than the public house'. The magistrate was not convinced and the licence was transferred to Mr Sidney George Snow. A few months later and the Vulcan Homing Club was formed,

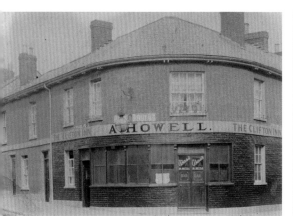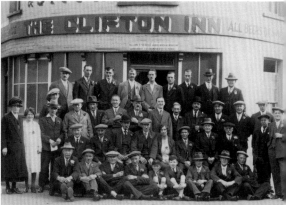

The Clifton Inn, *c*. First World War (*left*) and regulars in the 1920s (*right*).

based at the inn by enthusiastic pigeon fanciers in the area. They flew their first race from Whimple a few weeks later. Snow's young son fell down a gully outside the public house in May 1895. He claimed compensation of £2 from the council, stating that the child would have died if the accident had not been observed. Then, two years later, on 12 May 1897, the landlady 'dropped a paraffin lamp on seeing a rat in her bedroom. The premises were soon ablaze and considerable damage was done'.

The Twentieth Century

The Clifton Inn was occupied in 1902 by Daniel Elworthy. By 1916, Mr A Howell was in occupancy, and by 1919, the landlady was Mrs Ellen Howell. By 1935, the landlord was William T. Searle. Judging from the notices in the newspapers, the Clifton Inn did not keep a landlord for long, apart from the first, Mr Beedell. One past landlord during the later half of the century was Tony Kellow, a retired Exeter City footballer. He is remembered with affection by Grecian fans for the contribution he made playing for City during the 1970s and '80s, and becoming the club's highest scorer, coming second in a poll as the greatest player for Exeter after Alan Banks. Like all good pubs, the Clifton Inn ran a darts teams, and in 1937, in the Exeter Darts League knock-out competition, the Clifton Inn beat the Windsor Castle in the final, winning the Whiteway Challenge Cup. Newtown was badly hit during the Exeter Blitz, and the inn was lucky to be damaged, rather than destroyed during this time, when it was hit by incendiary bombs; thirty-six pubs and clubs were lost during the raid.

The Modern Inn

Michaela and Simon Welland have run the inn since 1995. They have recently started to open for lunches, serving a range of wholesome pub food. Michaela, who is the chef, said to the *Express and Echo*, 'We provide a whole range of familiar English dishes, such as cottage pie, hot pots, sausage and mash, lamb stew, jacket potatoes and fish and chips.' Their Sunday carvery is popular with the locals, and there is seating for eighty servings.

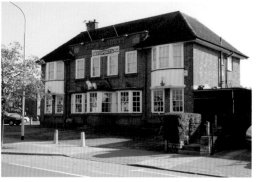

The Dolphin, Preston Street, c. 1925 (*left*) and the Dolphin (Tap and Barrel), Burnthouse Lane (*right*).

DOLPHIN INN, Burnthouse Lane

The Dolphin public house in Burnthouse Lane can be traced back for hundreds of years to the West Quarter and Tudor times, through its old name the Dolphin. The original Dolphin Inn was situated on the corner of Preston Street and Market Street. It belonged to the Courtenay's or the Guild of Merchant Venturers, and was mentioned in a document in 1578. Before it became an important carrier inn, it was, like the nearby Mermaid, often frequented by guests of a higher class. As trade increased into and out of the city, it became one of many inns that were used by carriers to collect and deliver goods from around Devon.

Pengelly's Gift

In 1700, the owner of the Dolphin, Francis Pengelly, an Exeter apothecary, gave for charitable use the inn and two adjoining houses. The gift was not to commence until after the death of Joan, his wife. The inn remained unlet for a week in 1725 and was kept open by trustees. Their records indicate that carriers from Moreton, Yeovil, Ashburton, Totnes and Okehampton stayed at the inn, with fifty-six pack horses stabled at sixpence per night, per horse. In the nineteenth century, there was a Wednesday and Saturday service run by Abbot to Ashburton, while Frost & Co. ran a Saturday service to Bath. The inn was sold in 1806 for £650. The money raised from the sale was invested and the return was divided between ten poor people, educated six or seven poor boys, and a sum given to the Devon and Exeter Hospital and to the poor prisoners in the city gaol at the Southgate. In March 1844, it was again for sale with 'large Room, Bar, Tradesman's Room, 4 Parlours, 10 Bed Rooms, Kitchen Cellars, large Yard, Skittle Alley, Lock-up Warehouses ... and Granary'. The next year, it had become Boon's Dolphin Inn and was hosting the Exeter Western Conservative Society. Thomas Upright, son of James Upright the owner of the City Mill, took on the Dolphin in 1857.

Ancient Order of Druids

The Ancient Order of Druids used the Dolphin for their meetings in the mid-1880s. The Isca Centenary Lodge, No. 672, met there in July 1883 to initiate six new honoury

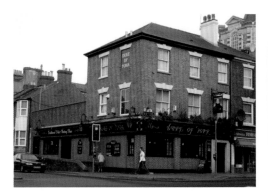

The modern Duke of York (*left*) and the Edwardian Duke of York (*right*).

members. Citizens of substance belonged to the Druids, and in January 1884, Colonel Walrond MP and the Sheriff of Exeter were initiated as members.

The New Dolphin

On 6 February 1931, Exeter magistrates granted the transfer of the licence from the Dolphin in Market Street to a new Dolphin public house in Burnthouse Lane, and the old premises were retired. The Dolphin Inn, Burnthouse Lane, was damaged by an air raid on 17 June 1941, along with a number of other properties in the area. The water main was badly damaged in Burnthouse Lane and a car with a loudspeaker was sent to inform the locals to boil all water for at least five minutes. The pub was renamed the Tap and Barrel in 1991, and after a time, became very run down. It closed for a while and reopened as the Dolphin Inn in 2006. Debra and Graham Densham, the present landlords, won the Community Pub of the Year for the Dolphin at the St Austell Brewery Estate Awards in 2010. It is very much a community pub for the residents of the Burnthouse Estate, and they offer karaoke nights, a pool table, dart board, fruit machines and a Juke box in the bar along with a beer garden in the summer.

DUKE OF YORK, Sidwell Street

Situated on the corner of York Road and Sidwell Street, this public house is older than it looks. The area had significance to the Romans as they built a cemetery in the York Road, Wells Street area just behind the pub, and the famed St Sidwells well was also situated nearby. The earliest mention in the *Flying Post* of the Duke of York is an advert for the sale of the 'well accustomed public-house situate in St Sidwells aforesaid, and now in the Occupation of Mr Raddon' in August 1801. The first listing in a trade directory was in 1822, with Harriet Land as the landlady. She was the widow of the celebrated John Land who had built the New London Inn and also ran the Half Moon Hotel, before becoming the wealthiest landlord in the West Country. She remarried Mr Richardson of the Home East India Co. in March 1827. The Duke of York was for sale, along with the dwelling houses of Nelson Place in December 1832, although Harriet Richardson continued as the landlady.

The house was for sale in April 1845, with Mr Stoneman in occupancy, at a yearly rent of £42:

comprising a good Bar, Bar Parlour, Tap Room, Tradesman's Room, Kitchen, spacious Club Room, and suitable Bed Rooms, a good Brew House, extensive Beer Cellars, Curtilage, and every convenience for carrying on an extensive trade. These Premises are held under a Lease from the Dean and Chapter of Exeter, for 31 years, from 29th September 1837, under the Yearly Rent of 18s, renewable every 10 Years, on payment of a moderate fine.

The next landlord was a family man, with his wife giving birth at the Duke of York in 1849 to a son, and in 1852, a daughter. The following occupier, Mr Davy, became embroiled in a dispute with a hop dealer during 1856, when he denied having taken delivery of a half pocket of hops. The dealer submitted an invoice for £12 3s 4d. Payment was not made, forcing him to take Davy to court. After the jury failed to agree, a majority found for the defendant, and he was acquitted to an excited and packed court. John Iley took on the Duke of York, along with his wife, in July 1848. The High Constable asked for references and a week later, Iley appeared with testimonials from about a dozen people from Taunton, but not his previous employer. The licence was granted on a temporary basis. The following August, an officer of the law named Superintendent Steele, from Taunton, arrived with a warrant for their arrest. He searched the Duke of York, to find a large leather trunk full of items that belonged to Iley's previous employer. It transpired that Mrs Iley was named Rogers and the pair were wanted for robbing their master, the Rev. Dr Moysey of Bathalton, Somerset. The pair were committed for trial at the Somerset Assizes, found guilty and imprisoned with twelve months' hard labour.

In the mid-nineteenth century, St Sidwells was fast expanding and many public houses were used for sales of building land and dwellings. One such sale was at the Duke of York in January 1867 when seven tenanted houses, all in Sandford Street, were put up for sale. The Duke of York was lucky to survive the Blitz of May 1942. The Acland Arms, on the opposite corner of York Road, was destroyed by fire, and most of the opposite side of Sidwell Street was also lost. The Duke of York is still frequented by many locals and visitors to the Odeon just up the road. It also does well when Exeter City are playing at home.

GREAT WESTERN HOTEL, St David's Station

It is not difficult to account for the name and position of this hotel, as it is right next to St David's Station on Brunel's Great Western Railway. The Great Western Railway arrived in Exeter in 1844. The line was opened by the mayor, and the first train engine, *The City of Exeter*, was welcomed into the terminus by a large crowd. Seven trains departed for London Paddington that day. To take advantage of the many passengers passing through the station, and in competition with the nearby Red Cow Inn, an inn confusingly named Railway Station was opened in 1848 to the north of the station, and was promoted with an advert in the *Flying Post*:

RAILWAY STATION, EXETER

JAMES HUTCHINGS avails himself of this opportunity, to return his thanks to his Friends and the Public, for the favours already bestowed on him, since he has opened the above Inn, and trusts by strict attention to the Comfort of Visitors to merit a continuation of their support.

Visitors will find every accommodation, and attention combined with moderate charges. Genuine Wines, Spirits, &c. GOOD BEDS, STABLING AND LOCKUP COACH HOUSES

The Inn being so near the Station, Travellers, by rail, will find it a great accommodation. Families supplied with Good House Brewed Beer.

The railway network in Devon was still limited, and North Devon and the North Cornish coast had no rail service. In 1856, Hutchings Railway Hotel was an agent for coach tickets to and from Bude and Copplestone, which was timed to the mail train to and from Bristol and London. The coach service ran three times a week at a cost of 7s 6d. James Hutchings became a respected man and he was voted chairman of the Licensed Victuallers Protection Society in 1861, at the thirteenth annual meeting held at his hotel. He died in 1863, and the hotel was sold to James Underhill the next year. Underhill advertised the hotel as the Railway, Family and Commercial Hotel. The hotel offered stabling, lock-up coach houses and an attendant on every train. The hotel remained under James Underhill's management until his death at the age of sixty-four in July 1894.

The hotel is in three distinct sections, with the earlier Railway Hotel on the corner of the Crediton Road (now Cowley Bridge Road). A small, three-storey extension was probably added by James Underhill, according to the evidence of the OS maps. The third, four-storey building dates from 1902, when an article appeared in the *Building News*, along with an artist's impression of the new Great Western Hotel:

 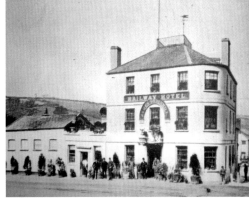

The modern Great Western Hotel (*left*) and the hotel, *c.* 1903 (*right*).

The Great Western Hotel Bar.

It is proposed to erect this building close to the main station of the Great Western Railway, St David's, at Exeter. The site is a commanding one, facing the chief approach to the station, and overlooking the delightful valley of the Exe. There are some acres of ornamental grounds in front, and a tramway leads from the station and hotel to the city. When erected it, will be a great boon to travellers to and from the West by the Great Western system, enabling them to stop near the station, and, after exploring the 'Ever Faithful' city, to resume their journey in either direction by that Company's splendid service.

Trust House
The Public Home Trust Company was the idea of the fourth Earl Gray in 1904. By the end of the nineteenth century, many country inns and hotels were struggling, due to the loss of passing trade after coaching services stopped. The result was that many inns pushed the consumption of alcohol, to increase turnover. Earl Gray intended that each county form a public trust with investment from prominent local families. The intention was to support local inns helping them to provide food and accommodation, and reduce drunkenness. The first Trust House was acquired in Hertfordshire. By 1909, the Great Western Hotel was a Trust House.

Mrs Emmeline Pankhurst visited the Great Western Hotel on one notable occasion in 1913. Due to her agitation for women's suffrage, she was subject to the so called Cat and Mouse Act (when the authorities would imprison her, and release her when she went on hunger strike, to then arrest her again when she had recovered). On

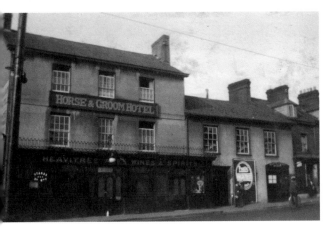
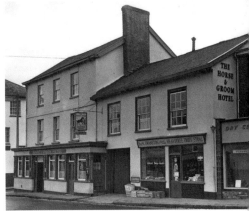

Two historic photographs of the Horse and Groom, *c.* 1920s (*left*) and *c.* 1950s (*right*).

4 December, after she had visited the United States, she was arrested on the White Star liner *SS Majestic*, when it anchored in Cawsands Bay, Plymouth on her return. She was brought by car over Dartmoor to be incarcerated at Exeter Prison. On 7 December, she was released on seven-day's licence, and proceeded to the Great Western Hotel, where a reporter from the *Express and Echo* spoke with her. She said she had spent a bad night and was only able to take invalid food. Mrs Pankhurst also spoke of the good treatment she received in the prison. She then left on the 10.15 a.m. train to Paddington, accompanied by friends.

THE HORSE AND GROOM, Heavitree
Along with the Ship (& Pelican) on the opposite corner of Church Street, this house dates back to 1740. Called the Horse and Jockey until about 1830, the newspapers would variously use both names until about 1840. The house was a popular refreshment stop for many when following the cart carrying the condemned to their execution at Gallows Cross at Ringswell. The building was often used as a public assembly room before school buildings became available for public use. The public house was also used for providing refreshments after a pauper's funeral. There was an allowance of 3*s* (15 pence) per burial, which was paid up until the 1820s.

Throughout the nineteenth century, the house was the venue for many inquests and property auctions. One dinner for 100 friends of Lord Ebrington in 1830 required a long shed to be erected beside the skittle ally, in order to accommodate the event. Another interesting dinner was held for 105 workers for the Exeter foundry Messrs. Kingdon; the firm would eventually become Garton and King, whose name is still trading today.

The landlords of the Horse and Groom appeared in the courts for several misdemeanours. In 1877, Isaac Cutler was summoned for purchasing three pairs of Army boots from a gunner in the Royal Horse Artillery. The gunner claimed he did not know that it was illegal to sell Army equipment without permission from his commanding officer. The case was dismissed. The house, along with a cottage at No. 1 Church Street, was sold by auction in April 1891 for £1,925 to a buyer from

Dawlish. By June of the same year, the newly incorporated Heavitree Brewery were the owners and it became the first public house to be owned by the brewery, which was down Church Street, a few dozen yards away. The first licensee for the new owners was George Allsop, who took on the house with his wife Charlotte in the May. It would seem that running a public house was too much of a strain for Allsop, for in the October, the licence was transferred to his wife; he had been admitted to an asylum as he had lost his sanity.

The Exeter City and Arsenal footballer Cliff Bastin ran the Horse and Groom for a time in the 1950s. Bastin was Arsenal's highest goal scorer until Ian Wright, and he played for England twenty-one times. The building to the right, with the double-garage front, is now part of the public house. It used to house Exeter Fire Brigades, Heavitree's District Fire Station. When the Danes Castle Fire Station opened in 1932, this station, along with all other district stations, was closed. The building then became Swanston's fruit and vegetable shop and then an extension of the pub. The public house was renamed The Heavitree on 4 August 2006. Some locals did not approve of the name change, and a 300-name petition was raised to prevent the rename, to no avail. However, the Heavitree Brewery had a change of heart in 2012, and the name has reverted to the Horse and Groom.

HOUR GLASS INN, Melbourne Street

One of a diminishing number of local city pubs to survive in Exeter, the Hour Glass Inn is notable for its rounded wedge shape, at the junction of Melbourne Street and Colleton Row. The earliest mention to be found in the local newspapers is in July 1847 when John Stuckes the landlord applied to the Improvement Commission for the path near to the house to be flagged, for improved access. Along with the improved pavement, Stuckes improved the house, for in September 1848 he announced an annual dinner to celebrate the recent extensive

alterations and improvements, and he flatter himself that the accommodation which his house now affords is not to be equalled by any similar establishment in the city The very commodious enclosed SKITTLE ALLEY has also been much improved, and gentlemen will now find it adapted for play at all seasons, without their amusement being at all interfered with by the weather.

John Stuckes moved on to the Black Lions Inn, South Street in March 1849, and the Hour Glass was for sale freehold:

Situate on the Friars, Exeter, and near the principal thoroughfare from Exeter to Topsham; together also with the PREMISES adjoining thereto, now in the occupation Mr. John Stuckes, the Owner. The Premises are nearly new and in good repair, and consist of a good bar, parlour, dining-room, tap-room, kitchen, 7 bed-rooms, brew-house, wash-house, beer and wine cellars, with other necessary requisite offices, and an enclosed skittle-alley, with very large room over same, which could be easily converted into a very superior Malt-house, or small Tenements, at a very moderate outlay.

Within a few months, Stuckes was declared bankrupt for the sum of £700. It would appear that he had raised a mortgage on the Hour Glass to fund his move, and in 1851, a sale was ordered by the mortgagees of the house. It was in the occupation of Mr John Parsons Jnr and included the adjoining property in the occupation of Mr John Barker, along with several unfinished tenements that were to the rear of the inn. John Parsons had a sideline selling dog carts, flies and phaetons; he was the equivalent of a second-hand car dealer. Many adverts appeared from 1853 through to 1855 for his carts, when the licence was transferred to Silas Godwin. Parsons still held the freehold, and in 1856 he put the Hour Glass up for sale.

The house went through several licensees up until 1861, when in the July, the premises were temporarily shut. By 1865, it was open again as a meeting place for the Friends of Labour Loan Society, although the society did not stay, as they transferred to the Oddfellows Arms in 1867. As was common in those days, the house played host to other societies, such as the Rational Sick and Burial Society. In a time with no welfare state, working people formed beneficial organisations for mutual support. William Daymond died in January 1869, at the age of thirty-nine after a long illness. About a hundred members of the Sick and Burial Society attended his funeral wearing black sashes, as Daymond was a founder member.

The owner, John Parsons, was declared bankrupt, owing money to two mortgagees of the Hour Glass, and in April 1870, the house was for sale again. Mrs Daymond was still in occupation and in September 1871, she was unsuccessfully prosecuted for allowing card playing and gambling on the premises. Through this time, several inquests were held for drownings in the river, due to the proximity of the premises to the quay. In 1882, the licence transferred, after almost twenty years, from Sophia Daymond to Ernest Phear. By 1900, the house was under the City Brewery, and the licence newly transferred to Mr W. H. Miller.

Unless an event such as a fire or an interesting crime takes place at a public house, there is often little to mark its progress through time, other than changes of landlords or social events. In the case of the Hour Glass, the visit to Weymouth by fifty-three customers of the inn was the high point of 1923. They left Exeter at 7 a.m. for Weymouth, 'The Naples of England' according to the report, where they gained a fine view of the Channel fleet at anchor. The modern-day Hour Glass Inn has had to change with the times, offering food from its restaurant, with a separate bar.

THE IMPERIAL HOTEL, New North Road

Elmfield House

On 19 January 1809, the *Exeter Flying Post* carried the following advert: 'To be sold, 34 Elm Trees of large dimensions now growing in a field on St David's Hill. Auction at the Plume of Feathers, Saturday 28 January. For viewing apply to Messrs Hicks and Son.'

The trees stood on six acres of land belonging to James Green, the County Surveyor, who built the Exeter canal basin. It was he who posted the advert to clear the trees to make room for his family home. Elmfield House, designed by Green, was completed

The Orangery, The Imperial Hotel.

in 1810. The original entrance, complete with lodge for the estate, was located on the corner of St David's Hill and Howell Road. Green sold the house sometime around about 1822 to George Sparkes, a member of a Quaker family that owned the General Bank in Exeter. The next prominent owner of Elmfield was John Hall Gage, a serving Army officer, who moved in during 1835. He had been a prisoner of war of the French after being shipwrecked near Calais, and served at the Cape of Good Hope and Mauritius, before retiring with the rank of General in 1841. He died in 1854, leaving his wife living at the house until her death in 1864. William Danby and his wife moved into the house in 1865. Originally from Yorkshire, he was a Land and Fund Holder. When he died in 1897, his estate was worth £105,217 13s 8d, an amount that is the equivalent of several million today. A stained-glass window and brass plaque were installed in St David's church by his daughter, in memory of her parents. In 1898, several speculative builders offered more than the asking price for the house and grounds, but were turned down in favour of William Buller Heberden, who purchased the house. He had recently retired from being Joint Secretary of the Board of Inland Revenue. He went to school in Exmouth with his cousin, General Redvers Buller. William Heberden made many improvements to the grounds of Elmfield and planted many cedars and firs along with a pond and fountain. It was Heberden who installed the barrel-vaulted conservatory, known as the Orangery, which had previously been part of Streatham House.

The Imperial Hotel
The house was then sold and converted into a twenty-nine bedroom hotel by Mrs Pollard. A new entrance was made from New North Road and a drive that swept round to the front entrance. Renamed the Imperial Hotel, it opened in May 1923.

The Jolly Porter, formerly the Elmfield Hotel.

It was conveniently situated for St David's station and was on a tram route into the city. In its heyday, in the summer months, guests were entertained at dinner by the 'Imperial Orchestra'. The gardens could provide the hotel with fresh vegetables, and fruit from its Peach House and vineries were available throughout the year. Through the 1920s, the hotel gained in popularity, and many organisations used its facilities. Every Christmas and New Year, a full programme of dinner dances were held. One year, a Cinderella Dance was held, at which a shoe was hidden in the ballroom at midnight and the guests then had to find it. The play *Fame*, which was performed at the Theatre Royal in September 1929, after a run at St James Theatre, London, was written by sisters Audrey and Waveney Carten while staying at the Imperial Hotel. The play is about an unknown violinist, who marries the daughter of an aristocrat and has an attack of paralysis at the height of his fame.

After the Second World War, the hotel held sales of wool for the Ministry of Agriculture, a trade that was at its height in the seventeenth and eighteenth centuries. In the late 1980s, the Williams-Hawkes family, who had run the hotel for forty years, sold it to a Plymouth accountant. It almost became an annex of Exeter College before J D Wetherspoon purchased it in 1994, and opened their first outlet in Exeter in March 1996.

JOLLY PORTER

This once popular hotel and public house is now a hybrid Chinese takeaway, restaurant and pub. Situated opposite Brunel's handsome St David's station, it was called the Elmfield Hotel. It was ideally placed to provide refreshment for travellers coming to and from the station by coach and horse omnibus from the city centre. From 1882, it

was on a handy horse-drawn, and later electric, tram line to the city centre. One source indicates the site was originally a water mill, driven by the Taddyforde Brook. If it was, it was most likely a corn mill.

A New Hotel
Edwin Banfield is responsible for opening the newly built Elmfield Hotel in June 1863.

> BANFIELD'S ELMFIELD INN, COMMERCIAL AND FAMILY HOTEL, opposite the Railway Station, St David's, Exeter, is now opened, and the Proprietor trusts that his establishment will deserve the patronage of all classes. By moderate charges, he hopes to command a liberal share of support.

Banfield, a former agricultural labourer, lived at Elmfield Cottage. It is probable that the cottage was rebuilt as the Elmfield Hotel, which would become the first of at least three establishments that he and his son, Douglas, would become associated with. The next September, he applied for a wine and spirit licence. In 1879, the hotel hosted the annual Railway Employees' Supper of the Great Western Railway. It also hosted, in 1882, a special meeting of the Loyal Samaritan Lodge 540 of the Ancient Order of Druids, when the mayor was initiated as an honorary member. The 1881 census still lists Banfield at the hotel, along with his wife and a gaggle of boarders and servants. His son Douglas, who had taken over the Elmfield by 1897, was in 1881 an engine fitter. The parent lodge of the United Ancient Order of Druids used the hotel for meetings in the 1870s. The order was a sick benefit and funeral society for working men. The Banfields continued to run the hotel until 1907 when it was put on the market and sold.

The Elmfield was renamed the Jolly Porter in 1957. In 1988, the name was briefly changed to George's Drink and Food Factory after the Hofmeister Bear used in television adverts at that time. During the last few years, the Jolly Porter has played host to many bands and groups. One such band were the Bootleg Beatles, who filled the place with pure nostalgia. During 2006, the Jolly Porter was closed for a refurbishment. However, the decline continued until part of the premises was opened as a Chinese restaurant, a fate that is becoming increasingly common for many public houses.

THE MILL ON THE EXE, Bonhay Road

Head Weir Paper Mill
This pub and restaurant occupies part of a former fulling and paper mill that was located just below Blackaller Weir, on the River Exe. Woollen cloth was fulled (a process that cleans and softens) from before the sixteenth century on this site. It was let in 1787 for milling corn and then in 1798, Edward Pim started papermaking in the mill. Pim was bankrupt by May 1814 according to the *Flying Post*:

> To be sold... All those extensive paper mills, capable of working 8 vats at one time, in which the paper manufactory has for many years been carried on by Messrs. Pims ... situated near Engine Bridge.

The Mill on the Exe is on the site of Head Wear Mill (*right*).

Coldridge's survey of 1818 noted it as 'Mr Pim's Paper Mills and Grist Mills'; perhaps the purchaser had retained Pim to run the mill. It was quite common for mills to engage in other activities, probably at slack periods, and it was relatively easily for the machinery to be converted from one process to another. From 1832, Tremlett & Harris were making paper, with the Tremlett family continuing at Head Weir until after the First World War. Charles Harris and his partner Edward Norish Tremlett invented a new process of production in 1836. The partnership was dissolved in 1844, with Harris moving to the Countess Weir Mill. Edward Tremlett was succeeded by William Tremlett. One woman employed at the mill was Sarah Chapman, aged ninety-four, and who is described as an assistant at paper mill; there was no pension in those days. Paper mill workers were often forced to live in the most overcrowded and insanitary areas of the city, with the Head Weir Mill drawing much of its labour from Exe Street. In 1851, nine paper workers lived in Exe Street. The area had a lower mortality rate during the 1833 cholera outbreak than other parts of the city, which was probably down to the fresh water available at Blackaller leat. In June 1851, a House of Commons report noted that the mill had four working beating engines and one idle; 'Hollander' beating engines were used to separate the cellulose fibres in the rags to produce pulp.

Fire and Rebuilding

In 1882, the mill was badly damaged by fire requiring the building to be reconstructed out of brick, and the addition of a small Robey steam turbine to power the mill when the water was low. A set of drying cylinders, manufactured by Bentley and Johnson, were also installed. Just after the First World War, the mill was then taken over by E. S. & A. Robinson of Bristol. Before the mill closed in July 1967, it was producing 50

tons of paper per week for tickets, sugar paper and laminating. In 1982, the mill was demolished and the next year, the Mill on the Exe was constructed on the site, using bricks from the old mill buildings. Many think that the pub inhabits part of the old mill buildings, but photographs of the partly demolished mill show quite clearly that the Mill on the Exe is largely a reconstruction. It is also apparent that much of the car park was originally mill building. The lower floors of the pub suffer from intermittent flooding, and it was badly affected in October 2000, when the house was forced to close to recover. In time of flood, Blackaller Weir is a most impressive site, just below the car park, and you may even see the flash of a salmon as it fights its way up the river to spawn on Exmoor while you drink your pint. The Mill on the Exe offers beer from St Austell Brewery and snacks through to full meals on two floors.

MOUNT RADFORD, Magdalen Road

The present Mount Radford Inn is at the heart of the village like the Magdalen Road area of the city. And, yet, the first Mount Radford Arms opened in 1833 in Magdalen Street, when the licensee John Mitchell hosted a dinner for fifty to mark the opening of his inn. In 1834, thirty-three years after the Battle of Copenhagen, a procession went from the Mount Radford to the house of Humphrey Ley, pump maker, to crown him King for the day; he claimed he was a survivor of the battle fought by Nelson. He was then treated to a dinner in his honour at the inn. Ley was quite a character, and in another celebration at the Radford, when he was to lay the foundations for a house he was building, some cannons were fired as a salute, hitting a member of the brass band with some wadding and removing his right eye. The Mount Radford was closed and demolished for road widening in 1840, and the New Mount Radford opened in Magdalen Road, opposite the corner of St Leonards Road, with legendary Humphrey Ley as landlord. Ley hosted several wrestling matches at his inn, in a ring at the rear, including one match for twenty sovereigns in July 1850. Humphrey Ley died in 1857, aged sixty-eight years. Ley's wife's family continued to run the Mount

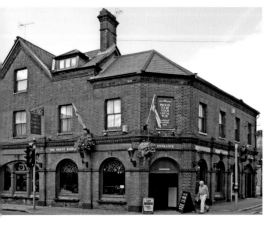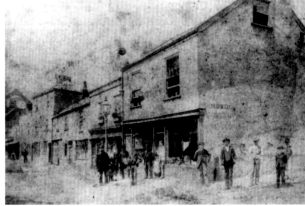

The Mount Radford, c. 2005 (*left*) and c. 1880 (*right*).

Radford, where, in 1870, his daughter Sarah died from poisoning by laudanum. The licence was transferred from Mary Ley to Joseph Henry Warren in 1876.

In 1885, the city council purchased a portion of the property for road improvement, and the remainder was sold, with recommendation that a first -class hotel be constructed on the site. James John Norman purchased the site and built a shop, warerooms and business premises. Norman was already running a grocery business elsewhere in Magdalen Street. He developed the Mount Radford Inn as a wine and spirit business, which traded into the 1950s as J J Norman and Ellery. Norman, who was remembered as forever cheerful, died aged sixty-one on Christmas Day 1909, leaving £8,420 in his will and the business for his daughter, Lucy Anne Norman, to continue. Frank Hanks Sutton managed the business for many years until his death in 1946. A fire in 1983 closed the pub for five months, giving an excuse to completely refurbish the place. It has a large, sports-orientated bar, and a smaller bar frequented by locals.

NEW LONDON INN, London Inn Square

The New London Inn was considered in its time to be one of the most luxurious inns in the city. It was built in 1793/94 for Mr John Land, who had previously owned the Half Moon Inn and the Old London Inn. The inn was built on the site of the Oxford Inn, which had closed in March 1790. The architects were Matthew and Thomas Nosworthy, who were responsible for Dix's Field and Barnfield Crescent. It had an open court, and was resplendent with pot plants and palms.

The Coach to London

In an age of travel by stagecoach, the inn had extensive detached stabling and could cater for 300 horses per day. In 1800, the Mercury left the New London Inn at 3.45 a.m. every day and reached London the next day at noon, a time of 32 ½ hours. Later, the Quicksilver became the fastest coach in England, and in 1844 made the London to New London Inn run in 17 to 18 hours, an average of 10 miles per hour at the trot. When the railway arrived at St David's, the coaching companies could no longer compete on the long runs, so they timed their local services to coincide with the London train. John Land quickly became the wealthiest landlord in the West Country, and also the oldest when he died, aged eighty-seven, on 24 January 1817. The streets of Exeter were lined with people for his funeral cortege to Pinhoe church. The hearse was drawn by six horses, followed by eight coaches, fifteen post chaises and 160 gentlemen on horseback.

Distinguished Visitors

In 1833, the young Princess Victoria made her first of two fleeting visits to Exeter (the second as Queen), when in August 1833, she stood in her carriage outside the New London Inn 'and bowed in the most amiable and condescending manner to the assembled multitude. Victoria was not the only future monarch to visit and the Prince and Princess of Wales, the future King George V and Queen Mary, stayed for tea at the hotel in 1899. Charles Dickens often stayed at the inn when visiting his parents, who lived in Alphington. A little earlier in the century, Jane Austen mentions the New

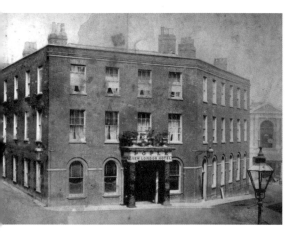 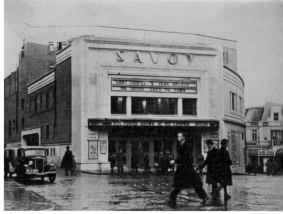

The New London Inn, *c.* 1890 (*left*) and the ABC/Savoy that replaced it (*right*).

London Inn in her novel *Sense and Sensibility*, while the Duke of Wellington stayed there in 1819. Robert Louis Stevenson was a guest in 1885 when he suffered from a haemorrhage. He wrote in the visitors' book,

> I cannot go without recording my obligations to everyone in the house; if it is your fate to fall sick at an inn, pray heaven it may be the New London.

In 1892, Beatrix Potter turned away from the door 'with the wisdom of bitter experience' after what must have been a disappointing stay.

Pople's Hotel

From January 1869, the landlord was Robert Pople, who had previously run the Half Moon Inn. Pople was sheriff in 1890 and a very popular mayor for three years running from 1895. He gained fame when he was praised for his efforts to save lives during the Theatre Royal fire in 1887. He quickly produced ladders by which more than fifty people were saved. He opened his household to tend to the survivors and laid out the dead in the courtyard and stable yard at the rear of the inn. The inn became known as Pople's New London Inn and at one time had a large sign across the front saying just 'Pople's'. In 1898, Pople was made an honorary freeman of the city. He died in 1909 at the age of seventy-two, with the hotel left in the care of his daughter.

The Twentieth Century

By 1907, the horses were gone and the hotel had parking space for fifty cars. It continued to attract distinguished visitors including American composer John Philip Sousa in 1911. Trade declined after the First World War, and the New London Inn was sold to Associated British Cinemas Co., for the Savoy Cinema, and closed on 2 November 1935. The sale of furnishings and fittings from sixty bedrooms took place in November 1935. When the old building was demolished in 1936, 12 tons of lead

was removed from the site and sold. The new cinema did commemorate the old inn with the inclusion of the aptly named London Inn bar on the ground floor, next to the main entrance. The cinema was demolished in 1987, and the site is now Waterstones bookshop.

ODDFELLOWS, New North Road

Oddfellows in New North Road occupies the end property in what appears to be a terrace of houses that were constructed at different times. Edward Jackson, a former coach maker, ran the Northernhay Hotel, before it was acquired by the London and South Western Railway Hotel. It became the Locomotive Inn. Jackson owned a piece of ground almost opposite the Locomotive, on which he built a house in 1859. He applied for a licence, which was refused on the grounds that the building was unfinished. Within months, the house, with bar, smoking room and taproom, along with a double house and two unfinished cottages, were for sale. Mr William Nosworthy purchased the still to trade inn, named it the Odd Fellows Arms, and opened for business in 1861. He welcomed the newly formed Exeter Friends of Labour Loan Society to the house in 1863 and the Odd Fellows Society, from which Nosworthy had named his house for their meetings. He was sympathetic to liberal causes, including the Reform League and Liberal Association, which were welcomed at the Odd Fellows. The proximity to Queen Street Station ensured a steady trade, and 'Mr. Nosworthy, of the Odd Fellows Arms, New North-road, had "command" of a party of seventy in five breaks' when the Tiverton races were held in 1868.

Daniel Jackman

The reputation of the house deteriorated after Nosworthy left, and in 1883, after Norman and Pring (City Brewery) became the owners. The licensee, Mr Daniel Jackman, was summoned for opening on Sundays, after several anonymous letters were received by the police. Daniel Jackman was an enthusiastic pike fisherman, and reported to have caught a pike weighing nearly 40lbs in March 1900, in the River Exe. The opening of the Theatre Royal just across the road in 1886 brought a boost to the business, and tragedy, when his fourteen-year-old son, Frederick, was one of the missing after the fire that killed almost 200 in September 1887 at the theatre. Mr and Mrs Jackman celebrated their golden wedding anniversary in 1922, and were still running the Odd Fellows after fifty years in 1929. When he first moved in, he brewed his own beer, before it became a City Brewery house. By December 1929, he was the longest serving tenancy on the brewery books. The licence was transferred from Daniel Jackman to Mr Hartnoll in 1931.

Monkey Business

Occasionally, there is an incident involving a public house that you couldn't make up. In August 1910, it was reported in the *Western Times* that a baboon and a small Guereza monkey escaped from Boswell's Stage Circus, who were appearing on stage at the Theatre Royal. The pair broke out from a dressing room, through a window and proceeded down New North Road, pursued by an enthusiastic crowd of onlookers.

When the animals reached the Odd Fellows, to escape their pursuers, they slipped through the open door and entered an empty room. Someone shut the door, locking the monkeys in, and their keeper was summoned. The keeper and his assistant arrived and entered the room, armed with a stick. The baboon leapt at him, but after a short tussle he was pacified, along with his friend, and the two returned to the theatre (probably complaining that they hadn't been allowed to finish their drink). It emerged that the two animals were inseparable, and it wasn't the first time they had made a bid for freedom.

Oddfellows (as it had become known) made the newspapers in November 1988, when Michelle Gavin, who was expecting twins at the time, lost her flat and possessions in a fire in Sidwell Street. The landlord of Oddfellows heard of her plight and raised money to help her by charging customers 50 pence to make a hand print on a newly painted white ceiling. It was in the mid-1990s that the pub was renamed The Gate and opened as Exeter's first and only cider bar. Then The Gate closed and it became an Irish theme pub named Molloys. In early 2000, there was another rename, to the quirky Thirsty Camel. Since then, the house has returned to its original name to become a gastropub, specialising in English style food.

OLD FIRE HOUSE, New North Road

This was the original West of England Fire Insurance Company Fire Station from 1834 to 1888. During the nineteenth century, Exeter had gained something of a reputation as the 'fiery city', and the fire stations' fire appliances, along with those from competitor insurance companies, would race each other to a burning building. In 1878, the captain of the fire brigade was one John Henry Zelley. The station buildings housed the stone-paved engine house and stabling for the horses. Stairs and a trapdoor hoist led to two large workshops above the engine house. A trapdoor in the ceiling of one gave access to the roof where there was a wooden platform, used for drying the hose. After the Theatre Royal burnt down with a loss of 186 lives in September 1887, ironically only 50 metres from the Fire House, the city formed its own fire service, the Exeter Municipal Fire Brigade. They purchased the old fire house and the equipment of the various city insurance company services.

From 1888, the superintendent of the fire brigade was William Pett, who had under him a chief officer, an engineer and eighteen men. The original No. 1 Engine (dating from 1807) that was used during the Theatre Royal fire and known as 'Little West', was retired and put on display in Finance House, Bedford Street, for many years. The Old Fire House appears to be on a very cramped site, with a small exercise yard at the front. In 1931, the City Fire Brigade moved up to a new fire station at Danes Castle, and the Old Fire House was sold for £1,500. It was used for various purposes over the intervening years, and during the Second World War, it was an army recruitment office. From 1959 to the 1970s, the Co-operative Retail Services used the premises for a warehouse, followed for a short time by Miller & Lilley, who ran a solid fuel order office. By 1986, the building was derelict, when it was sold and refurbished as a public house.

The Old Fire House's main bar is squeezed into the small L-shaped building; the small front yard has seating in good weather. It is popular with students and locals,

who can drink amidst the original firemen's helmets. The Old Fire House has live music in the downstairs bar, while two upper rooms are open for private parties and other events.

THE PORT ROYAL INN, St Leonard's Quay

It is not certain when the Port Royal first traded, but the earliest date in the papers is for an inquest in 1843. In 1844, Robert Ugler is listed as the landlord, but his time at the Port Royal was short lived; by 1847, George Webber was running the house. Boating on the Exe was an integral part of the Port Royal from the beginning, and Webber was an enthusiastic boatman. He raced gigs, which he also hired out. He brought a case against six men for damaging one of his racing gigs, which was housed at a boat yard at Teignmouth. The last time Webber was mentioned was in 1855 when he advertised a punt for sale. Just between 1844 and 1854, there are at least twenty-three inquests for bodies found drowned in the river. There were ten inquests for babies, several newborn, and in one case, twin toddlers were sadly judged to have been drowned by their insane mother. The Port Royal was the nearest public house to the tragedies, and was the preferred venue for the coroners court.

The Whirlwind

On 7 September 1850, a four-oared gig moored next to the building was picked up by a sudden swirling wind and lifted some 15 foot above the river. As amazed customers looked on, the boat was dropped back into the water. The incident was reported in the *Illustrated London News* on 14 September with this statement from George Webber, the landlord:

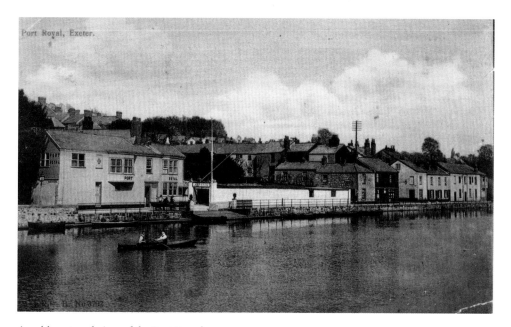

An old postcard view of the Port Royal.

On Saturday afternoon last, between the hours of three and four, whilst working in his shed, his attention was arrested by a loud rushing sound, which proceeded from a path immediately outside the building. On hastening thither he saw large stones, dust, etc., taken up as in a whirlwind, from a space on the ground as large as a coach-wheel. The revolving column gradually drew towards a small punt afloat in the adjacent river and moored to a post by the bank; the boat was then lifted as high in the air as the painter would allow, and was held there by the force of the wind, spinning round like a top. The column then moved on towards a four-oared gig, moored in a similar manner; when simultaneously the punt fell and the gig was elevated precisely from the water, whilst the stern was raised about fifteen feet. The column then seemed to have expanded its strength and fell, so to speak, in water, with the noise of a ton weight, dashing and stirring up the bed of the river with foam. The gig is thirty feet long and had in her at the time such was taken up from twelve to fifteen gallons of water: she has been rendered quite useless. What renders the occurrence the more remarkable is that at the time scarcely a breath of wind was stirring, and the sky was nearly cloudless.

Landlord Charles Edwards

On 29 September 1855 Charles Edwards became the most influential licensee that would ever run the Port Royal. A former sea captain and son of the ferry operator at the quay, Edwards would dominate leisure boating on the Exe for the next sixty-five or so years. He was twenty-six years old, just married, with his first child on the way. Edwards became involved in organising the annual Exeter Regatta, and was also treasurer of the Ancient Order of Foresters, who would often meet at the Port Royal. Maude Alice Richards from Kent was a personal guest of Charles Edwards, when she visited him in September 1887. She attended the performance of *Romany Rye* at the Theatre Royal the night the theatre was burnt down. She died in the inferno and her body was identified by her husband. Charles Edwards died at the end of 1923 at the age of ninety-three, making his tenure of the Port Royal at least sixty-six years. After his death, about forty new and second-hand boats belonging to Edwards were auctioned.

Exeter Rowing Club

The Exeter Amateur Rowing Club was first established in 1863 at the Port Royal, with Charles Edwards an active member. By 1866, the club had eight boats including an eight oar outrigger. After the death of Charles Edwards in 1923, Alfred Dorothy, who for seven years running was West of England pairs champion with his brother, took on the Port Royal in 1924. He founded the Port Royal Rowing Club in 1926, which was still flourishing when he died in 1938. In 1927, the Port Royal Amateur Rowing Club was formed by Dorothy, which was merged with the Exeter Amateur Rowing Club in 1946 to form the Exeter Rowing Club. In 1930, the pub was taken over by Norman and Pring of the City Brewery. The link with rowing was maintained when a new boat house was opened in 1952. Exeter Rowing Club finally vacated their clubhouse at the pub in 1981 and, in 1982, their old club house was converted into a function room. Further improvements have been made and the owners claim that the Port Royal is the longest pub building in Exeter.

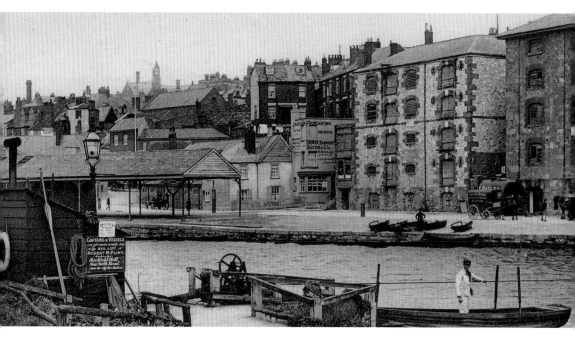

The Prospect Inn in the late nineteenth century.

THE PROSPECT INN, Exeter Quay

There probably isn't a quayside in the country that does not have one or more public houses nearby, and Exeter quay is no exception. The Prospect Inn at the bottom of Quay Steps was well placed for serving seamen, quay workers and others to slake their thirsts. The earliest known landlord is Richard Sercombe, who was a ferry man of Trinity parish in 1803 and is probably responsible for opening the house in the ferryman's cottage. This was another public house that appeared to have two names at the same time. The Bell and cottages were for sale in September 1823, and were described thus:

> Lot 4: For the residue of a Term of 99 years, determinable on the death of a healthy person, aged about 39 years, all that Public-House, called THE BELL, situate near the Quay Steps, with TWO COTTAGES and GARDENS, in Horse Lane, in the Parish of Holy Trinity, in the County of the City of Exeter, now in respective Possessions of Mr Sercombe and others as Tenants.

Sercombe's wife, Elizabeth, was found drowned in the river a month later, aged sixty-six. Her body was fished out of the water near Salmon Pool and taken to the Exeter Humane Society, near the Lime Kilns, where attempts were made to revive her. Her bonnet and other items of clothing were found on the bank nearby. When Sercombe died, just three weeks after his wife was buried, the inn was referred to as the Fountain. The Prospect Steps to the right of the inn are part of an old right of way from the Quay to Southernhay and date from 1835. From 1842, to 1856, James Venn was the licensee. He left on the death of his wife, and Simon Westlake took over

the licence. The reputation of the Fountain was poor in the 1860s and '70s, as some licence renewals were questioned, and the house was often likened to a brothel. The many seamen and quay workers would have attracted working women to the house from the impoverished West Quarter. The Exeter Working Men's Annual Regatta had its committee room at the Fountain Inn in 1892, and Samuel Gregory was the Honourable Secretary and Manager.

A Win for Charity

In 1957, the *Daily Sketch* offered the refurbished and renamed Prospect Inn as a prize in a readers' competition. The winners, Frank and Alma Ward from Hull, were handed the keys by Diana Dors, with a large crowd in attendance. They gained a reputation for raising money for the Vranch House School, the Devon & Exeter Spastics Society and the Exeter Swimming Club, through collecting at the bar and running charity events. In 1961, Jimmy Edwards, the actor, visited the house to push over a pile of pennies on the bar, which were to go to the Vranch House School. They ran the pub for several years, before retiring back in Hull. The original public house consisted of the building at the rear. All the quay in front of the house is reclaimed land, so it is probable that the ferry ran from close to the cottage, across to Haven Banks. The front section was originally the site of three transit bays at the end of Quay House, the original transit shed. The bays were incorporated into the Prospect, sometime in the late twentieth century.

ROYAL CLARENCE HOTEL, Cathedral Close

On 7 September 1770, an advert placed by the French proprietor Pierre Berlon used the French word *hôtel* for the first time in England, when he opened in the new Assembly Rooms, constructed just the year before by William Mackworth Praed. Exeter had become the trailblazer in sophistication with this Gallic import. Over the next few years, the facility grew, as a succession of proprietors made their mark on the business. In 1776, Richard Lloyd, the former proprietor of the Swan Inn situated in the high street, announced that he had 'now taken the HOTEL, in St Peter's Church-Yard, which is fitted up in the most elegant manner'. Although initially just called 'The Hotel', it became The Cadogen Hotel for a short time, then Thompson's after Thomas Thompson, which it remained for twenty years. It was Phillip's Hotel by 1799. Jenkin's *1806 History of Exeter* described the hotel thus:

> The only house, worthy of notice in its parish is, The Hotel, a large commodious Inn, with elegant apartments and Hotel accommodation for people of the first quality, with a large assembly room in which assize balls, concerts and assemblies of the most distinguished persons of City and Country take place, in the front is a neat coffee room. The situation of 'The Hotel' is very pleasant as it opens to the parade and commands a noble view of the Cathedral.

In July 1827, Street's Hotel became known as Street's Royal Clarence Hotel after the Duchess of Clarence (Queen Adelaide), wife of the future William IV, had stayed there a couple of months before.

The Royal Clarence Hotel (*left*) and guests' parking, 1928 (*right*).

Famous Visitors

When Admiral Nelson passed through Exeter after the Battle of the Nile, he received the freedom of the city in 1801. He was presented with a sword at the Guildhall, where he was to be entertained with dinner. However, Nelson insisted in returning to Phillip's Hotel, where he was staying, to address the gathered newspaper correspondents before dining at the hotel. It was in the hotel during 1815 that a meeting was held to plan the introduction of gas to light the streets of the city. Exeter was the first place in Devon to pioneer town gas, and the first gas lights were installed in the high street. In August 1840, Franz Liszt gave a piano recital at the Royal Clarence while touring England with a small group.

During the age of the stagecoach, Exeter's inns and hotels competed for business for prestigious services. The Royal Clarence was no exception, as it offered its clientele the Royal Bath and the London Mail services. After a particularly frightening accident, in which a Clarence-bound stagecoach ran amok across the Close when it clipped the narrow entrance of the Broadgate, the city authorities demolished the old gate and eased the entrance to the Close.

The Twentieth Century

Thomas Hardy and his second wife stayed at the Royal Clarence in 1915, while visiting a friend in Torquay. In 1916, the Clarence opened the first cocktail bar, called the Zodiac Bar. During 1939, such exotic drinks as Tugboat Annie, the Corpse Reviver and Gloom Chaser were concocted to cheer up Exonians heading into the Second World War. Such bars were popular in the '20s and '30s, and it was the talented Mr 'Ginger' Wood who invented the Gloom Chaser, one of fifty-one different cocktails available at the bar. During the Second World War, when the Americans were based in Exeter before D-Day, both Clark Gable and Gary Cooper stayed at the Royal Clarence while they served in the US air force.

Banking and Pubs

The Exeter Bank was situated to the right of the hotel. It became the first Deller's Café in Exeter during 1906. The building is now part of the Royal Clarence and is run by Michael Caine, the Exeter-born celebrity chef, as the Abode Café Bar and Grill. On the opposite side, the Well House Tavern is also owned and run by the Clarence. The original building was a Norman hall and was constructed on part of the medieval burial ground, before tenements were built in the fifteenth century. The upper floors were added in the seventeenth century. Veitch's, the nursery and seed merchant, occupied the premises as a shop until the early 1980s, when it briefly became an estate agent, a bookshop and then the Well House in 1984.

The royal crest on the front façade of the building originally dated from when the hotel gained royal patronage from the Duchess of Clarence. In 1989, it was decided that it should be refurbished. The crest was lowered to the ground and found to be in a very poor condition. The Vulcan Works in Water Lane gained the contract to make an exact copy out of fibreglass. It took three months before it was ready and put back in place. The Royal Clarence is now part of Michael Caine's Abode group of hotels. It offers gourmet food and a high class of accommodation in Cathedral Close. With views of the Cathedral, and a unique history, it is one of Exeter's historic gems.

THE RUSTY BIKE, Howell Road

This public house is better known as the Eagle Tavern for many Exonians. Howell Road was known as Red Lane before it became Barrack Road in 1792, when the Higher Barracks were built to garrison cavalry troops at the time of a feared invasion by Napoleon. This was an area ripe for a public house, and duly, the Marquis of Wellington opened on this site sometime before 1815. It was renamed the Duke of Wellington, with Richard Tapper as the innkeeper. It again changed its name in 1833, when it became known as the Spread Eagle.

> TO PUBLICANS
> ELIGIBLE SITUATION FOR BUSINESS
> To be LET, for a Term of Years, with immediate possession, all that well-accustomed PUBLIC HOUSE, called the SPREAD EAGLE, situate close to the Cavalry Barracks, in the Parish of Saint David, and possessing every convenience for carrying on an extensive trade.
> For viewing, and other particulars, application may be made to Mr Simon Hore, St Thomas: or to Mr SAMUEL KINGDON, solicitor, Bedford-street
> Exeter, 18th October, 1833.

Sid Rowsell, a former landlord of the Eagle, believes that the name Spread Eagle derives from the Spread Eagle Standard carried by Napoleon's troops at Waterloo. The Standard was captured from the French by the Royal Dragoon Scots Guards, and held to this day by the regiment. In 1844, it became known as the Eagle Tavern, with William Crabb as landlord. By 1850, Iron Sam Kingdon, former mayor and owner of Kingdon's Foundry, owned the house, and John Martin was landlord. Martin ran

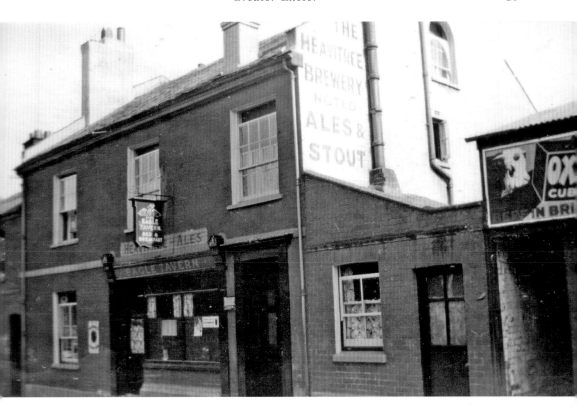

Above: The Eagle Tavern, before it was the Rusty Bike.

Right: The barman calls time on the last night of the Eagle.

a quadrille band that had been formed two years before and was engaged to play at the Cullompton Ball in 1850. By 1859, William Pinney was the licensee, when it was known as Pinney's Spread Eagle. After an epidemic of Asiatic cholera in 1866, the City Corporation discussed using the premises as an isolation hospital for new cholera cases, but the plans were never put into action.

In December 1865, there was a sale of household goods, brewing utensils, stock in trade, and skittle alley at the Eagle Tavern, the effects of Mr Clarke. The changes of licensees continued in 1869, when Mr Abbot took over from Mr Knight. Samuel Reed was in charge of the Eagle Tavern in 1871 and, in June 1873, E. Langford announced his occupancy, with improvements to the pleasure and recreation ground attached to the house, as well as the stocking of Burton Ales. Under the landlord Richard Lethaby, a long forgotten feat of endurance and world record attempt was made in the Eagle's pleasure garden. On 19 June 1877, twenty-year-old Mademoiselle Price (aka Eda Anderson) started a 1,000 mile walk in 1,000 hours. By 12 July, she had travelled 554 miles, completing the walk on 31 July. She covered a mile in about fifteen minutes, and then rested for the rest of the hour. Engaged to do the marathon by Mr Martin, who ran the Northernhay Skating Rink, Price slept in a tent in the grounds, while a bedroom at the Eagle Tavern was occupied by her assistant. The event ended in acrimony, when one evening Mrs Lethaby presented Price with a bill for the use of the tavern's facilities. Lethaby went on to tell Price that unless she paid, she was to stop walking, and end the attempt. Price said, 'You can take the things, but you won't have any money', just as Mrs Lethaby picked up a tray of cups and saucers. Price then struck the tray, breaking the crockery, and threw something in Mrs Lethaby's face. Mr Lethaby appeared and called a policeman. In the meantime, Price is said to have used a horsewhip to thrash Mr Lethaby. The magistrate found Price guilty of both assaults and fined her, with additional costs for the damage. Whether Mademoiselle Price broke her own walking record is not reported.

The Heavitree Brewery took the inn over in 1892. In 1897, Kelly's Directory listed Edward Ernest Hill as the publican, while in 1923, the landlady was a Mrs Emily Hill, the former incumbent's wife.

The Twentieth Century

It was in 1928 that Sonny (Charlie) and Rose Stone ran the public house, eventually moving on in 1945. Then Richard Green and his wife Minnie, daughter of Sonny and Rose, took over. In later years, they were increasingly helped by Sid Rowsell and his wife Joan, Minnie's daughter, taking over in 1973. Joan Rowsell's father was her mother's first husband, George Shelton who ran the Bull with Minnie in Goldsmith Street. George was a retired Exeter City footballer who died at the early age of thirty-two. The Rowsells stepped down and Harry Peprell took over in 1975. There was a flurry of indignation from the publican and regulars in September 1981, when the Co-op announced plans to use the garage next door as a mortuary. The landlord used the *Express & Echo* to stop the plan. Later, in the 1980s, the former Exeter City star striker Tony Kellow was landlord. He was the highest scoring Exeter City footballer ever, with 129 goals. The Eagle Tavern closed on 6 June 2006, to be reopened in 2009 by Hamish Lothian, as the Rusty Bike.

Part III

West of the River

THE ADMIRAL VERNON, Alphington

The Admiral Vernon apartments in Alphington have a history that can be traced as far back as 1430, as the Bell Inn on the Chudleigh Road. Sir William Courtenay (died 1511) as owner of the manor of Alphington donated, in 1499, a parcel of land close to the church for a Church House. It was a Tudor style, thatched building that was to be used for parochial and manorial meetings. An inn called the Red Lion was established in part of the building. Income from leasing the land was to go for the upkeep of the church; in 1688, the annual rent and accrued interest of £5 was used to distribute bread to the poor of the parish. Later on, in 1784, it was leased for a further ninety-nine years at a yearly rental of £5.

Admiral Vernon

During the seventeenth century, the inn was used as a Court Leet for Criminal Cases, and a Court Baron for Parish cases. The inn was renamed the Vernons Head after Admiral Vernon, who took Porto Bello in 1739 with six ships. Admiral Vernon had been nicknamed Old Grog from the 'Grogram' cloak he wore on deck. He was concerned that the tot of rum that sailors were issued every day led to drunkenness and poor discipline. In 1740, he gave the order that rum...

> be every day mixed with the proportion of a quart of water to a half pint of rum, to be mixed in a scuttled butt kept for that purpose, and to be done upon the deck, and in the presence of the Lieutenant of the Watch ... and let those that are good husband men receive extra lime juice and sugar that it be made more palatable to them.

It was inevitable that sailors would nickname the rum ration 'grog', after the Admiral.

The Horse Fair

Alphington had two annual fairs: the Cattle Fair held at Midsummer and the Horse Fair at Michaelmas. The Horse Fair, established in 1632, attracted people from all over Devon. To cater for the influx, as many as twenty-three public or 'bush' houses opened to sell beer and cider. The Admiral Vernon pub would cook as many as sixty geese, and huge joints of meat to feed the throng. The fair was initially held in a field on the road

The Admiral Vernon before it finally closed (*left*) and the inn in the late nineteenth century (*right*).

leading to Shillingford, but was later moved to a site closer to the village, until the last fair in 1870.

In common with many inns during the nineteenth century, the Admiral Vernon held many sales. On 17 January 1837, a sale of 'Oak, Ash and Elm Timber Trees, with their tops and Bark' was held there. It was quite common to sell standing timber, and a good way of clearing the land. Not long afterwards, Charles Dickens is reputed to have drunk at the Vernon, while visiting his parents whom he had installed, during 1839, in Mile End Cottage in Church Lane.

Burnt to the Ground

On 15 September 1871, the Admiral Vernon and the rest of the historic Church House buildings were destroyed by fire. Two adjoining houses, occupied by Messrs Nosworthy & Buckbet and Mr Fry's butcher's shop, also went up in flames. The West of England Number 2, the Norwich and Sim attended along with one other engine to fight the flames. Unfortunately, there was a lack of water, forcing two of the appliances to convey water from a local brook. The delay allowed the fire to burn itself out, leaving smoke-blackened protruding walls. The site became the schoolmaster's house, next to the new Board School completed in 1878.

The Bell Tolls for Admiral Vernon

As already mentioned, there was an inn named the Bell on the Chudleigh Road, which belonged to the Courtenays. Conveyance records from 1849 show that land and a tenement were named the Old Bell, or Burgoynes, at this site. This was the property formerly used for coaching, part of which was leased to Richard and William Loram. Tracing the lessees of this property through the trade directories reveals that it reopened as the Bell Inn, with William Loram listed as farmer and victualler. The 1871 census confirms this, with Loram, his wife Mary and three daughters, and a son named William listed. Loram Close in Alphington is named after William Senior. On 26 September 1881, Husseys held a clearance sale at the Bell Inn, of livestock, poultry,

farm implements and produce still in the fields. On 29 September, it was leased to William J. Richards, who renamed it the Admiral Vernon Inn. The inn became a St Anne's Well Brewery house in December 1895. By 1964, the bars were significantly altered and a car park added at the rear. The house became a restaurant and a wine bar. It finally closed on 4 May 2006, bringing to an end more than 500 years of history. For the last session, the manager Matt Adolpho opened at 12 noon and was reported to say they would 'just keep going until we are dry'. In July 2007, permission was given to convert the Admiral Vernon into seven affordable homes. The building was granted a Grade II listing by English Heritage in January of the same year.

COWICK BARTON, Cowley Lane

The site of the Cowick Barton public house can be traced back to the twelfth century when it was part of the newly constructed Cowick Priory, which was situated a little to the east of the present house. It is possible, but not confirmed, that there was a home farm for the priory on the site of the house. The Priory became one of the holdings of the Monks of Tavistock in 1462. Henry VIII's Reformation was just as traumatic for the Monks of Cowick as it was for many other priories and abbeys around the country. Four months after the deed of surrender was signed in 1539, at Tavistock, the manors of Cowick and Exwick were given by Henry to Lord Russell, who evicted the monks. The priory church and buildings were quickly demolished, and the books and church ornaments sold.

The House

Lord Russell constructed Cowick Barton mansion in 1540, possibly using some of the stone from the demolished priory and church. It is thought that it was built to house his bailiff, who would administer his recently acquired manors. The house is constructed of Heavitree stone in the classic Tudor 'E' style layout. The plastered exterior retains its original stone mullioned windows along with the original three-storey porch and arched entrance. The building contained a stained-glass window, depicting the arms of Edward VI, Prince of Wales, which can now be found in the Victoria and Albert Museum. A chimney piece dating from 1657 has the arms of the Baron family above it. There are some plaster reliefs, one of a nun caring for some children and one of a maiden with long hair, both standing on the head of an obese friar. A Bible reference, 'I press towards the mark', is said to be a coded instruction for a priest hole. There is a trapdoor in the floor that leads to a cellar and passages that may have been the secret hideaway.

Sold On

Descendents of Lord Russell became the Earls of Bedford, with large estates in Devon and eastern England. The 4th Earl was involved in draining the Fens, an undertaking that proved to be more expensive than first envisioned. He sold the Manors of Cowick and Exwick to William Gould of Hayes in 1639, to concentrate on the Fens. Gould sold Cowick Barton house onto the Pate family, in 1641. On the death of Robert Pate, the house passed to his son in 1677. The document stipulated an annual payment of 20s be paid to the poor, administered by his son and a minister as thought fit. The house passed on to Mrs Prideaux through marriage, and then to her daughter, Mrs Speke. She

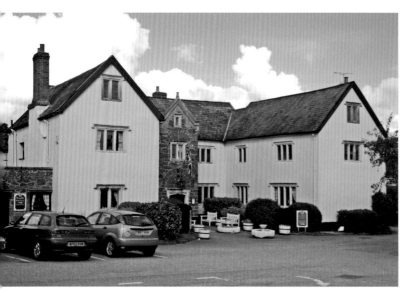

The Cowick Barton is a historic farmhouse (*left*). Here it is before it became a public house (*right*).

The bar at the Cowick Barton.

left it to Mr James White, who continued the habit of making an annual payment for a good cause. In his case, it was 30*s* to keep a schoolmistress for instructing four poor children of St Thomas, in reading only. The tenant of Cowick Barton was also required to make an annual payment of sixpence to each of forty persons of the parish.

John White-Abbott (1763–1851) was a water colourist of some note, and grandson of James. He restored the house in the early nineteenth century. The house then passed through several families, including John Terrel, who is noted for importing a pure Guernsey herd of cows in 1854. In 1920, the farm was sold off in lots, with the house and 11 acres going for £2,450. From the 1920s to the 1960s, the house was occupied by the Simmons family. By 1963, the house was abandoned and semi-derelict. A brewery purchased the house and turned it into the Cowick Barton public house that stands today. For some reason, the public house has become a favourite of believers in the supernatural. One such apparition is a monk who supposedly walks around the house. The pub was the venue for The Weird Weekend, run by the Centre for Fortean Zoology, from 2003. The Cowick Barton offers a fine menu, using local Devon produce. There is a hall with a capacity of thirty-two, which is popular for wedding functions.

CRAWFORD HOTEL, Alphington Road

The Crawford Hotel was built in 1825 as a Georgian merchant's residence named Lion House. The earliest known occupier was Mr Benjamin J. Myers Esq, in 1856, who was an active member of Exeter's synagogue. An article in the *Flying Post* of 1894 recounted an anecdote about Myer's son. The young man was said to be 'mentally afflicted, but quite harmless and inoffensive'. He enjoyed walking, sweeping along wearing a long cloak. People would say 'fine day, Mr. Myers', to which he would reply, 'I haven't tasted it yet.' He was fond of wearing 'coarse gipsy attire' and yet he liked to dine in evening dress.

Myers died at the age of eighty-three in February 1883, and a month later, his household furniture, horse, carriage and equipment were auctioned. The house was described in an April 1883 notice of sale in the *Gazette*.

> The house is of Classic design, the three main facades have handsome colonnades between the projecting wings, and contains on the ground floor, handsome drawing room, 26ft. 6in. by 16ft. 4in., and 12ft. 6in. high, with three windows opening to a conservatory running the whole width of the house, a marble mantelpiece, fine cornice and centre flower; dining-room, breakfast-room, kitchens, scullery, pantry, and offices; spacious entrance hall, lobby, with ornamental carved ceiling; good staircase leading to corridor, upon which open onto four bedrooms and dressing-room, all light and lofty, with fireplace each. There are also two servants' bedrooms, approached by back staircase from the kitchen; wine-cellar, coal-cellars, washhouse, with copper furnace; pump, with excellent supply of water.

Traction Engine Proprietor

The *Gazette* again announced the sale of the house in April 1904 to Henry Arden, a traction engine proprietor. Just six months later, Henry Peter Channing was living in the

house and standing as a Conservative for Cowick Ward. Channing remained at the house until it was sold in June 1913 to Mr Charles Claridge, a timber merchant at the canal basin. An article in the *Western Times* in 1916, about a flag day in aid of Russia named the house as the Crawford Lodge for the first time. Claridge was a keen fisherman, for in 1921, he advertised several times for '... salmon fishing for one or two rods'. In July 1921, he was prosecuted for having six stand-pipes attached to his water service pipe, contrary to regulations. He paid £1 per year for the use of a single hose in the garden, while the council had never had a case before of six stand-pipes. He was fined 40s.

Becomes a Hotel

In 1938, the city council decided to purchase Crawford Lodge, and the adjacent land behind Omega Villas for a planned cattle market. The intention was that the Lodge would be a hotel to service the new market; however, Claridge was not prepared to sell the house, forcing a compulsorily purchase. The house was offered to the breweries as a hotel, with the City Brewery offering the highest price. Converted into a hotel, it opened in October 1939 as '...the best equipped hotel of its size in the City'. The hotel closed around 2010, and remained boarded up until 2013. The Crawford was purchased by the Southern Co-operative Society and converted into a convenience store, creating fourteen jobs.

DOUBLE LOCKS

The Double Locks is a popular inn to pass a lazy sunny afternoon with a drink or a tasty meal. Built in 1701, as a lock-keeper's cottage, when Trew's original canal was extended, it doubled as the lock-keeper's house and inn from the late eighteenth century. It was constructed of small Dutch bricks that were imported as ballast from Holland. In the next expansion of the canal in the 1820s, the engineer James Green rebuilt the Double Locks, reusing some of the earlier bricks along with more modern, locally made stock. A towpath was added to each side of the canal to allow larger ships to be towed by horses, the Double Locks providing stabling for the horses.

A strange little story appeared in a June 1825 issue of the *Flying Post*. A rumour appeared in the local newspapers that the lock-keeper had refused to allow the body of man drowned in the canal to be placed in his house. The paper printed a statement, acquitting the landlord of the slur and giving the true story. The landlord, Mr Perryman, was not at home at the time of the incident and the body was conveyed to the House of Reception at the Exeter Lime Kilns. The article clears his wife '...and exculpates Mrs. Perryman (who was much hurried) from the slightest imputation of inhumanity or neglect'.

Lightning Strike

A terrific thunderstorm hit the city in 1852, on which the *Times* reported:

> During the storm, a house, called Double Lock, on the banks of the Exeter Canal, was struck by the lightning. Some persons who were standing in the passage, at the back of the house, were struck by the electric fluid, and one of them, a gentleman named

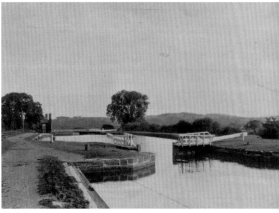

The Double Locks (*left*) is the place to go for a sunny afternoon drink. On the right is the lock after which the pub is named.

Burnham, was killed on the spot. He was struck on the head and died instantly. Two young men standing near the deceased were struck down, and their limbs, especially the lower extremeties, are paralyzed. Two persons were standing at the door of the passage where the catastrophe occurred, and it is a singular fact that the lightning passed over them, leaving them perfectly unhurt, and struck the group within the passage.

In October 1939, the lock-keeper found a female human leg wrapped in a brown paper parcel, when out patrolling his area. A search by two police officers revealed a second leg in a bed of reeds, also wrapped in brown paper. The police sent divers into the canal looking for a body, but none was ever found. Although there were five people missing from Exeter at the time, two of whom were women, the police decided that a medical student had disposed of the legs as a joke. George Hutchings was the lock keeper in the 1950s, having served in the Royal Engineers in the Second World War. On 30 November 1963, he watched the All Blacks beat the South West Counties 38–6 at the County Ground, with some old wartime comrades. They visited a pub after the match, before they were offered a lift home. At 5 a.m. the next morning, the wife of one of the men alerted the police that her husband had not returned home. The police searched and discovered skid and tyre marks on the canal bank. The water was 20 foot deep and murky, so two members of the John Webber Sub Aqua Club were called to dive the canal. They discovered the car with the bodies of the three men. A crane belonging to Exeter City Council hauled the car out and the bodies of Hutchings and two others, who were then taken to the mortuary.

The Locks
The locks are the longest in the country, at 95 metres long by 8 metres wide. They can fit two ships at once – hence 'the double locks'. When the York Class Cruiser HMS *Exeter* was refitted in 1938, the old masts were used as the arms on the lock gates. A

visit on a bicycle or by foot on a hot sunny afternoon is very pleasant, or better still take a non-drinking driver.

THE KINGS, Cowick Street

The Kings in Cowick Street was originally the King's Arms, named after George IV. Situated next to Brunel's railway viaduct, carrying the line to Plymouth, there has been a public house on this site from at least 1828, when the first landlord, John Adams, is listed in an early street directory. He was a family man who had four young daughters. The freehold of the King's Arms was for sale in May 1854, and this appeared in the *Western Times*:

> Lot I. All that old-established and well-accustomed Inn, called 'The Kings Arms,' situate fronting Cowick-street, in the parish of St Thomas the Apostle, with the Yards, Stables, Coach-houses, Brew house, Cellars, and all necessary offices, Skittle-alley and Garden, now in the occupation of Mr. Charles Holmes. These Premises are well situated for Business, being close to the St Thomas' Station on the South Devon Railway. The Purchaser of this Lot will be required to take the Stock-in-Trade, Brewing Utensils, and Fixtures at a valuation to be made the usual way.

Holmes moved on to the Sun Inn the next year. William Priston was landlord by 1873, and in trouble with the authorities in 1874. He leased a yard at the back as a slaughter house to Mrs Helms, a butcher. Through the yard ran a culverted stream into which drained the waste from the slaughter. The pair were charged with allowing blood and offal from the slaughter to enter the drain, and hence creating a large pool of effluent in Alphington Street. Mrs Helms was ordered to construct a drain into the public sewer, and Priston was ordered to pay costs.

Breakfast With a Bullock

William Priston was still the landlord when, in 1881, the *Western Times* reported the 'Alarming performances of a bullock'. A bullock was being driven through Cowick Street when the beast was startled, setting it off at a gallop. The animal ran under the railway bridge and entered the coal yard at the rear of the King's Arms. It then rushed into the public house through a passage adjoining the bar. Mr Priston and his family were taking breakfast in the kitchen when the bullock rushed in. The bullock was in the midst of the family circle, and placing his fore feet on the breakfast table, he was literally monarch of all he surveyed. Mr Priston was tossed into the corner and the family scattered. The crockery on the table was smashed to atoms. The animal lunged into the window, but the sound of the smashing glass frightened the beast, and only the timely opening of a door by a family member gave the animal the chance to escape down the passageway it had used to enter the house. It galloped back up Cowick Street towards the turnpike gate at Buddle Lane. Mr Priston was severely shaken but no bones were broken. The house and adjoining buildings were for sale in June 1890. The next year the licence was transferred to

The modern Kings, *c.* 2005 (*left*) and the Kings Arms, *c.* 1950 (*right*).

Mr Lamacraft, late of the Horse and Groom. In 1899, W. J. Crowson conveyed the house to the Heavitree Brewery.

The Twentieth Century

The new century opened with a new landlady, Mrs Lucy Duffett, who was still in charge until after the First World War. These years were a quiet time for the King's Arms, with a couple of cases of drunkenness and, in 1916, a 'Wanted' advert for help and a further sale advert for three horses and harnesses. After the war, horses and various carriages were often for sale from the King's Arms yard. By 1929, the age of the horse was over, and the King's Arms advertised a private car for hire, along with a careful driver. In 1929, Exeter was planning to scrap its trams, and widen some roads. The King's Arms was mentioned in one meeting, when it was said that the pub's lock-up garages had improved the property. Nonetheless, it was proposed that 35 feet of the frontage be removed, leaving the rear as a public house. Exeter City Council used a compulsory purchase order to acquire the house, in preparation for widening Cowick Street. The scheme was shelved, but it was a look to the future.

A fire in one of the garages at the rear of the house led to an incident in September 1940 that was described as one the most spectacular in the city for a long time. A fire in a car quickly spread through a large three-storey grain store, and a number of other garages behind the King's Arms. It was estimated that £30,000 of damage was done before it was extinguished. Later, air raid shelters were built by J. Wippell in the rear yard. In 1949, they were refurbished as garages, and handed over to Heavitree Breweries.

In the 1950s, the Heavitree Brewery embarked on modernising many of their pubs. The King's Arms was demolished, and a new public house built, set back just as envisioned in 1929. The rest of that side of Cowick Street was demolished and rebuilt during 1960. In 1974, Heavitree Brewery applied for permission to place a

Behind the bar at the Kings.

British Railways restaurant car beside the pub, to act as an overspill for the lounge bar. Although one councillor was in favour, the proposal was turned down. The old King's Arms became The Kings on 18 March 1999, and is still serving the public after almost 190 years.

MALTHOUSE, Haven Banks

This pub and family restaurant resides in an old Malthouse dating back to the eighteenth century. Brewing was well established in Exeter, for a growing urban population, and at its height, there were fifteen breweries in the city. A brewery and cellar were built in 1789 by the St Thomas' Brewery on Haven Banks, to a basic rectangular design, with one long side built as a curved wall. Three parallel, tiled roofs were built over. Two years later, a malthouse was added to the straight, long side of the original brewery.

Producing Malt

Malt is an important ingredient in the brewing process. Grain is slowly dried before it's steeped in water and spread over a frame to begin gemination for two to three days. The starch in the grain is converted into maltose. The sprouted grain is then heated in a malt kiln, which halts the germination and dries the grain. The last process removes the tiny rootlets that sprouted during germination. Both brewing and malting continued in the enlarged complex, and in 1833, the whole was incorporated into the City Brewery. By 1850, brewing had ceased and malting had taken over the whole of the premises.

In 1876, two small conical malting kilns were installed in the building on the opposite side to the riverbank. Extra floors were also added internally. In 1900, three larger conical malting kilns were added, one replacing an earlier kiln. The malthouse stopped production in September 1949.

The building was used as a bonded warehouse after it closed as a malthouse, unloved and unnoticed. In 1989, Lovell Urban Renewal of Swindon submitted plans to turn the building into a hotel. In 1995, Exeter Archeology investigated the site before Brewers Fayre refurbished it for a family pub, initially with a children's play area. It is now a Harvester pub and restaurant, with the main bar, and eating areas housed in the original building dating from 1791.

ROYAL OAK, Okehampton Street

This pub is not only the one remaining pub in Okehampton Street, but it is also the only remaining historic building on the river between Exe Bridge and the Okehampton Road railway bridge. Up until the Exeter Blitz, the Seven Stars Inn still existed adjacent to the Exe Bridge, along with the Okehampton Inn and Union Inn, all in the short space of 400 metres. The first mention in a trade directory of the Royal Oak was in *Besley's* of 1856 when M. C. Tuckett was the resident innkeeper. A fire during April 1869 in the premises of the adjoining Higgings and Clarke, fellmonger (a dealer of hides and skins), threatened the Royal Oak but for a change in the wind direction saving the inn from being engulfed in flame. As a precaution, the furniture was removed from the inn, while some outbuildings at the rear were damaged. A second fire in 1887 in an upstairs room quickly spread to the whole of the upper floor. A hose belonging to the local board was employed before the West of England, Norwich and Sun engines arrived to tackle the blaze. The upper storey was destroyed, while furniture below was water damaged.

Ice and Water

One morning in February 1929, when the barman came to draw beer through the pumps, it was found that the cold snap had frozen the underfloor pipes, preventing the beer from flowing. No doubt the customers turned to spirits to keep the cold out.

However, it is not fire for which the Royal Oak is remembered, but flooding. St Thomas has often suffered from flooding, and many buildings in Okehampton Street were regularly inundated. In 1726, it was noted that Okehampton Street '...to be ruinous and in decay, by reason whereof ye River Ex did overflow the Highway'. The Royal Oak suffered particularly badly in the St Thomas floods of 1960, when the torrent flowed though the streets and into homes. A DUKW was employed to pick up people from premises in Okehampton Street, including the Royal Oak.

The *Express and Echo* reported at length on the October floods and included an interview with Charles Lane, the licensee, who cemented that he spent

> a terrifying night ... It got so bad at lunchtime yesterday that a friend of mine, Mr. Ken Tallbay used a boat to take my wife down the street so she could go to her sisters. Mr Tallboy was coming back again to stay with me, but the current was too strong for

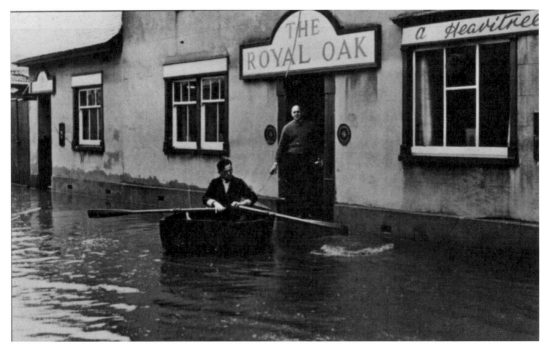

Boating weather at the Royal Oak in 1960.

The 'lost' beer barrel.

him to get through... I waded waist deep through the downstairs to rescue cigarettes and as much equipment as I could, and then I stayed the night upstairs... I could hear the water roaring past on both sides and there were crashes and bangs as tables and barrels were washed against the walls. I discovered this morning that I had lost between 18 and 20 barrels, some of them full of beer. They went washing down the river when the wall at the back broke. I reckon the damage has cost me about £200, and in a place like this you just can't get insurance for it.

A water mark on an internal wall was 22.5 cm above a painted mark for the last big flood in 1896. One of the lost barrels of beer swept away on the dreadful night was picked up by *HMS Highburton* on 8 December, seven miles off Portland. The selfless courage of the crew in saving the barrel was well repaid by the brewery and the barrel was turned into a seat complete with explanatory brass plaque, and placed in the public bar.

SEVEN STARS, OLD EXE BRIDGE AND ALPHINGTON ROAD
The modern Seven Stars Inn on the Alphington Road, opposite the retail park at Marsh Barton surprisingly has a very long history. The first Seven Stars Inn dates from the sixteenth century. It was situated on the riverbank, close to the old Exe Bridge in Okehampton Street, St Thomas. The roadway of the modern Exe Bridge roundabout passes over the site of the inn. George Fox, an early Quaker, preached from the Seven Stars in 1657. He wrote, 'We then travelled on till we came to Exeter; and at the sign of the Seven Stars, an inn at the bridge foot, had a general meeting of Friends out of Cornwall and Devonshire'.

The First Theatre
On 2 October 1721, an upper room at the Seven Stars was used as a regular theatre venue – the first in the city: '...many wonderful Fancies as dancing with swords by a little girl but ten years old, who turns many 100 times round with so swift a motion that it's scarce possible to distinguish her Face from the hinder part of her head.'

In 1725, *Brice's Weekly* published this advert for a return appearance for the girl, who appears not to have aged: 'Advert, of Punch's Theatre at the 7 Stars St Thos. Plays by artificial actors also legerdemain & a tumbling girl, 10 years old.' A legerdemain was one who perfumed a sleight of hand.

The venue became more prominent when, on 15 November 1728, John Gay's *Beggars Opera* was performed there, just months after the first performance at the Theatre Royal, London. In 1735, the thespians vacated the Seven Stars for a purpose-built theatre in Exeter, although the inn continued occasional performances up to November 1786. The landlord in 1857 was Thomas Hex, who had previously run the Plymouth Inn in Alphington Street. The stonemason and fledgeling artist William Widgery exhibited some Landseer copies at Hex's public house and encouraged by Hex, who recognised his talent, gave up his day job to become a professional artist. Widgery's son F. J. Widgery also became a successful artist, and was mayor of the city in 1903.

The Seven Stars was built to serve the cattle market.

Destroyed by Bombing

The freehold was purchased by the City Brewery in 1889, and by the First World War, the hotel benefited from trams passing on the way into the city. Although the site was purchased by the city council in 1931 for road widening, nothing was done, and the business was sold in 1933 for £8,000. Part of the premises were demolished for the road widening, but the adjacent building remained as licensed premises. In February 1940, at a licensing committee, it was noted that the Seven Stars was 'only a makeshift hotel, and it was a moot point whether it was structurally fit for the purpose of a hotel'. On 4 May 1942, eleven properties in Okehampton Street, including the Seven Stars Hotel, were destroyed by the largest raid of the war.

The Stars Shine Again

The Bonhay Cattle Market on the banks of the Exe, opposite the Seven Stars, closed and moved to a site on the Alphington Road, opposite Stone Lane, at the entrance to what would become Marsh Barton in November 1939. In July 1938, when the city council were negotiating over the move of the Bonhay Cattle Market, they agreed to purchase ¾ of an acre of land from Mr Physick, and sell it on to Carr and Quick, licensee of the Seven Stars Hotel. The new pub was delayed by the war, and it was not until 1965 that the new Seven Stars was opened opposite the cattle market at Stone Lane. Les Havill was the first landlord who managed it on behalf of Bass & Co. until November 1967. The cattle market has since closed to be replaced by the Stone Lane Retail Park in the 1980s, but the Seven Stars remains. It was refurbished in March 2003 and now offers an extensive food menu.

THE THATCHED HOUSE

Situated in Exwick, on the west side of the river, this public house was originally the farmhouse for Foxhays Farm, dating from the 1600s. The 1839 tithe map shows the farm buildings and fields around about and the owner James Wentworth Buller MP. The tenant was Henry Patch, who farmed a little over 25 acres of mixed beef and dairy. A sale in July 1858, due to the tenant George Webber quitting, indicates the farm by then had 17 acres of standing corn and 19 acres of barley. By 1874, the farm was occupied by John Robins, who by 1881 had expanded the land to a hundred acres. The farm had land on each side of the Exwick Road; the land towards the west and Cleve House was rising, while that to the east was flat water meadow and orchard, which is now the Exwick playing fields. In 1914 Albert Henry Guy was farming the land and running a haulage business; Guy's Road is named after him. In 1922, the long time owners, the Buller family, sold the farm to Mr Eastmond, with Albert Guy continuing as tenant. In the early 1930s, the road layout around the farmhouse changed when the end gable of the farmhouse was demolished, to allow Exwick Road to run straight past the end of the farmhouse.

The Farmhouse Becomes Cottages

By 1932, the farmhouse was divided into two cottages by its owner Mr Eastmond, who was a cider manufacturer and scrap dealer. Ivor Trivett, who was a baby at the time, explains:

> In about 1932 my father Wilfred Trivett met Reg Lobb in a pub where else, one Friday night and Reg said that he was going to see about a job next morning, Father decided to go along with him. They agreed to meet in the morning, when Reg did not arrive, Father went to get him only to find that Reg was still in bed, they finally arrived at Eastmond's yard in Exwick and Mr Eastmond gave Reg a job as a lorry driver, Father asked if there was another job available Mr Eastmond told him that he could have a job working in the yard which was accepted but he lived at Upton Pyne and wanted to move, so Mr Eastmond offered one of the farm cottages and he had a choice of two, Reg asked if he could have the other one but he was not married and was refused, [he] asked that if he got married by next Saturday could he have one which was agreed, Reg married Lou and moved in next door to Father, I was a baby at the time, we

Converted from a farmhouse, the Thatched House in the 1960s (*left*) and before 1938 (*right*).

become long lasting family friends. I believe that Mr Eastmond brought the land and the three cottages because he built Exwick Villas when the last pair of semi-detach was near completion. Father and Reg had to move out of the cottages and move there because Mr Eastmond had sold the cottages.

Eastmonds Yard

The year 1937 saw the building converted into a public house with E. W. Shire running the pub. In 1947, the house suffered a fire in its thatch, resulting in about a third of the roof sustaining damage. Customers rallied to fight the fire before the National Fire Service arrived with twenty men. Mrs Shire was still running the place in 1956. It has recently been refurbished with the outside repainted, and the thatched roof renewed. The interior is traditional, echoing its origins as a farmhouse, with little side rooms and inglenook fireplaces. It is a popular pub with locals, and they offer a good menu.

TURF LOCKS (HOTEL)

Positioned at the mouth of the Exeter Ship Canal, this hostelry was built to serve the lock at the mouth of the canal. In 1824, the County Surveyor James Green was given the task of extending the canal beyond the Topsham lock down to Turfe. The extension opened on 14 September 1827. Green employed 300 labourers to excavate the canal through very difficult ground. It ran close to the shore of the Exe as local landowners would not let him cut a direct route. The bank between the river and the canal proved to be a problem, and has had to be continually raised and strengthened in intervening years. The canal is 15 feet deep, built parallel with the estuary, has raised banks and was lined to prevent water loss. The lock itself is 131 feet long and 30 feet wide with a sill 2 feet below the bar at Exmouth. James Green's improvement to the canal and construction of Turf Lock increased the size of vessel that could reach the Port of Exeter.

Turf Locks Hotel

In 1827, the Turf Locks Hotel was built to provide accommodation for the lock-keeper and the crews of vessels using the canal. The hotel had stabling for the horses that were used to tow the barges up and down the waterway. The hotel was built on marshy ground without adequate foundations and still suffers from subsidence, giving uneven floors. It was originally built with a single toilet. The isolated nature of the Turf Locks meant that mains services were not available. It was not until 1957 that the Turf Locks had its first electricity supply, when the Navigation Committee approved the purchase of a generator and installation of wiring at a cost of £250. Prior to that, they relied on oil lamps, as the hotel is equally as far from a gas supply as it is from the electricity mains. In 1965, the South West Electricity Board agreed to install mains electricity for the first time under a special scheme recently introduced by the government.

The keeper, who was paid a salary by the city council, would also attempt to attract visitors to the hotel, to supplement his income. In 1868, John Edwards placed several adverts in the *Flying Post* offering 'Whitebait at Turf' along with tea, ham and eggs and wines and spirits. He would meet parties upon receipt of a letter with his boat at Topsham Ferry, and convey them to and from the inn for free. A few years later, the

The turf locks on a sunny day (*left*) and as a working lock (*right*).

same keeper was admonished for not only neglecting his duties as a lock-keeper, but allowing the grounds to become filthy.

In its heyday, the hotel would not only see the passage of many ships up the canal, but the entrance was busy, as lighters unloaded from large ships for transit to the basin. Coasters continued to use the Canal until the late 1960s, with the last commercial vessel passing through in 1998. The basin by the hotel was often full of ships waiting to be hauled by horse to Exeter Basin, or waiting for the high tide to enter the estuary. The decline of shipping using the canal in the twentieth century saw the hotel decline and, in the 1970s, the city council closed it. The Exeter Maritime Museum obtained listed building status for the hotel and a programme of restoration was undertaken.

The present owners, Clive and Ginny Redfern, have been at Turf since 1990 and continue to renovate and improve this fascinating and historical slate hung timber-framed building, being careful to retain its many interesting features and ensuring it is still a proper pub. There is a large beer garden bordered by the Exe Estuary on one side and Turf Locks on the other. Two large outdoor barbeques can be hired. There is no access for cars, although there is a ferry from Topsham and a seasonal boat service from the Double Locks. There is parking about a mile up the canal, and also by Powderham church. The surrounding wetlands and estuary are designated a Site of Special Scientific Interest (SSSI) and Special Protected Area (SPA).

THE VILLAGE INN, Exwick

The Village Inn occupies the site of the old Exwick Manor House, the home of Anthony Gibbs, father of William Gibbs of Tyntesfield, who became the richest merchant in England from the sale of guano during the nineteenth century. Part of the cob wall bounding St Andrew's Road and sections of some external and internal walls of the inn appear to date from the manor house.

When Exwick Manor House was sold in 1832, the new occupier of the premises took advantage of the Beer House Act, and opened as a beer house. In 1848, Thomas Shapter mentions the inn in his book about the cholera outbreak of 1832, albeit with the name that it was then known by: the Lamb Inn. He wrote that the landlord was summoned before the St Thomas Board of Health for advertising a forthcoming wrestling match

at the inn, while the cholera outbreak was raging through the city. A special constable was appointed to keep a watch and ensure the match did not take place.

Henry Hayman
From about 1855, Henry Hayman was the landlord of the Lamb, when his wife gave birth to their son. A notice for sale appeared, in the *Flying Post* in May 1865:

> MESSRS WARE and SON will offer for SALE, by Auction, at the LAMB INN, Exwick on TUESDAY, the 16th day of MAY instant, at Three o'Clock in the Afternoon, all that old established and well frequented HOSTELRY, called 'THE LAMB INN,' situate in Exwick, and now and for many years past in the occupation of Mr. Henry Hayman; also, a Cottage or Dwelling House adjoining the above Inn, now in the occupation of Mr. Bennett.

Either a buyer was not found, or he remained at the Lamb on a leasehold. Hayman remained running the inn until his death in 1879, aged sixty-one, leaving his son Harry Smith Hayman to manage the house. A mad dog foaming at the mouth rampaged through the village in the same year, biting other dogs, including two belonging to Harry Hayman. The animal and the bitten victims were swiftly destroyed. Harry Hayman was an enthusiastic fisherman, and he was recorded catching several salmon over the years from the Exe. They would have been a welcome addition to the fare at the inn. On one occasion he caught a 12 lb pike. Exwick had a busy flour mill in the village, and the Lamb would have been frequented by the mill workers and waggoners. In 1883, the waggoners met in protest at the inn, to complain about the weight of sacks of flour they had to convey to the bakers. In those days, a sack weighed 285 lb (129 kilos), and had to be manhandled up rickety ladders into the baker's loft. One waggoner had fallen to his death, and many were injured by the weight. The men demanded that the sacks be reduced in weight to 200 lb. The mill owners were in agreement with the waggoners, and it was only the bakers who were preventing the adoption of the lighter sacks. Mr Harry Smith Hayman retired and left the village in 1899; he was presented with a marble clock by the villagers. The annual beating of the bounds of Exeter would pass through Exwick Lamb Inn for refreshments. They were offered a refreshing drink of milk, which for older members of the party was laced with something stronger, the favourite being rum, before they set off towards Cowley Bridge, no doubt stopping for another tot of milk.

The Twentieth Century
During the early years of the last century, the inn was often used for social events, such as the Monday evening whist drive, and public meetings. A skittle alley was built when a cottage next to the inn was demolished. Two men from Exwick were taken prisoner by the Boers at Colenso and imprisoned at Waterval, while fighting in the Boer War. After they were released in 1907, Pte W. Bearmore and Pte Heard of the 2nd Devons were treated to a welcome celebration at the Lamb Inn, where fifty dined to hear their story. Pte Heard gave an account of the Battle of Colenso and their life as prisoners of war in Waterval.

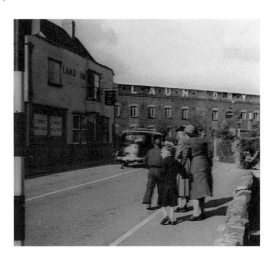

The Village Inn and Exwick Steam Laundry in the 1950s.

The inn was modernised by St Anne's Well Brewery in 1958. The Lamb Inn's name was changed in 1987 to the Village Inn. After nearly 200 years, the Village Inn is still serving the people of Exwick with their favourite tipple.

WELCOME INN

This very interesting hostelry is situated on the canal bank, near the gasworks and just outside of the canal basin. Originally named the Haven Banks Inn, The Welcome tearoom by the canal dates from just after the basin was opened in 1830, when the area was suddenly flooded with thirsty, working men. The first reference to the building as a hostelry was an announcement in June 1833 for the newly erected inn: 'Also a newly erected FREEHOLD DWELLING HOUSE situated on the Haven Banks, and known as the HAVEN BANKS INN with a slip of land adjoining to...'

In 1832, William Ellory was a brush maker in West Street. By 1833, he was the innkeeper of the Haven Banks Inn, making him the first landlord. The 1839, the tithe map for St Thomas shows the Haven Banks Inn, with the owner named as Joseph Green Bidwell, and the tenant Robert Powlesland. The tithe map shows the main building along with additional outbuildings. Powlesland became the owner of the house, along with five cottages next to the inn and other property in the same area. The first reference to the Welcome Inn was in 1854, although the inn was referred to as both the Haven Banks and Welcome Inn for a few more years. In 1857, Foster's Welcome Inn hosted a couple of wrestling matches, but it didn't improve the trade for the landlord William Foster who was insolvent in 1858. In 1859, the landlord was Robert Bailey, while Powlesland put the Welcome Inn up for sale in April 1861 as 'a large house formerly the Welcome Inn'. The inn reopened in 1862, and a new licence was issued to John Harris, a former whitesmith from Topsham, but he was soon summoned for out of hours drinking and fined 50s or a month in prison. His youngest son, John James Bishop Harris, became the manager of the gasworks behind the Welcome Inn.

The Welcome Inn was supplied with free gas from the Exeter Commercial Gas Light and Coke Company, which was to the rear of the inn. This rival to the Exe Island

based gas company opened on Haven Banks, behind the inn, in 1836. The Welcome Inn continued to be lit by gas until December 2011.

Inquests, Murder or Accident?

Because of its proximity to the canal and river, the Welcome Inn was the venue for more than a dozen inquests between 1855 and 1900. There were at least five suicides, four drownings through boating accidents, two died when a courting couple's boat went over Trews Weir, and several victims who fell into the unfenced canal at night. There was a lengthy inquest into the death of seventy-one-year-old Mr William Wreford in December 1852. Wreford was found drowned, possibly the victim of foul play. He had previously met a young woman named Slee at the Lower Market, after Wreford passed a note to her mother to arrange a meeting. He walked to the Haven Banks Inn, while the young woman followed at a discreet distance. When he reached the canal, there was a scream and locals who attended the scene found his body floating in the canal, his pockets emptied of money. The girl was distraught, claiming he was her uncle and was allowed to leave the scene. The next day she was arrested and held under suspicion of murder, but she was released as it remained unproven.

The Welcome Inn may have benefited from the proximity of the gasworks, but it did not enjoy such a favourable connection to the sewerage system. In May 1904, the city council discovered that the Welcome Inn along with Exe View Cottages were discharging their sewage directly into the canal, as their toilet facilities were fairly basic; they were described as a 'pail system'. Surveyors were engaged to plan a sewage system, but for some reason nothing happened. In December of the same year, the council abandoned the plan. As late as the 1990s, nothing had been done to connect the properties to the main drains. Anyone care to swim in the canal? The inn closed when longstanding landlady Dawn Jones died in 2009. The lease was sold in 2011 to Roger Olver, who reopened the business in April 2012 as the Welcome tearoom.

The Welcome Inn on the canal bank in the 1970s.

Part IV

Topsham Pubs

THE BRIDGE INN, Bridge Hill

The site of the Bridge Inn has been a dwelling from as early as 1086, when it was mentioned in the *Domesday Book*. Parts of the present inn date from the sixteenth century, when local stone was used in its construction, although the brew house at the rear is of Devon cob. The brew house contained the hop drying floor and is alongside a large brewing chimney. The *Sherbourne Mercury* contained an early sale notice for the Bridge Inn dating to October 1797, which details the building and land:

> TO be SOLD, The Fee-simple and Inheritance of All that Commodious Dwelling-House, known by the name of the TOPSHAM BRIDGE INN, Stable, Orchard, and Garden; a small field on the other side of the road, containing about two acres; two neat Dwellings, a Garden, and convenient Quay, with the Salt Refinery. For Sale of which a Public Survey will be held at the said inn, on Monday the 30th day of October instant, at three o clock in the afternoon.
> For viewing the premises apply to the tenants; and for particulars to Mr. Evans, salt-merchant; or to David Phillips, builder and auctioneer, Exeter.
> Exeter, October 12, 1797.

It is interesting that there was a salt refinery adjacent to the inn; this is an example of a public house attracting other trades, such as smithy, malting and salt making. Another sale in 1815 was the result of a court order made in the cause of The King against Francis Cox and Philip Pyle. Despite the order, Pyle's son, Philip Pyle Junior was still the owner of the premises in 1846, when his daughter was married. A peremptory sale of the Topsham Bridge Inn, with a dwelling house, was advertised in March 1850. Another notice in the 9 December 1863 issue of the *Flying Post* read, 'To be LET, immediately, a MALT HOUSE, at the Topsham Bridge Inn. For particulars apply at the Inn.'

Wrestling was a favourite sport in Devon during the nineteenth century, and many public houses and inns would arrange matches. A notice in the *Western Times* in 1839 stated:

> Wrestling at Topsham. A Purse of Sovereigns will be wrestled for at the Topsham Bridge Inn, on the Exmouth road, on Tuesday, Sept. 24th. The play to begin at 12 o'clock; good play is expected.

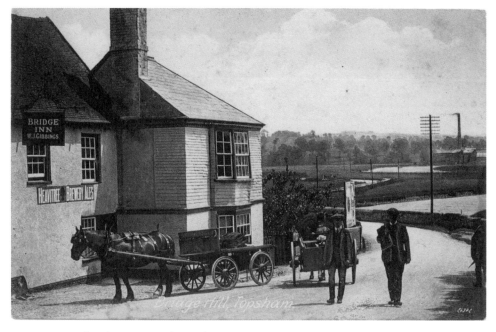

Two carters call in for a pint at the Bridge Inn.

At the turn of the twentieth century, the house was the venue for a series of cattle sales. It would have been a particularly suitable setting, away from the centre of Topsham and on the main Exmouth Road. Wartime was an interesting time for many public houses, and the Bridge was no exception. In May 1940, the Topsham British Legion held a 'Dug Out Supper' when seventy were treated to a dinner of bully beef, hot dogs, pickles and beer. The entrance was sandbagged and lit by candles in bottles, and music was played to entertain the guests. Ironically, this was only two weeks before Germany invaded Belgium and France, and within a month British troops were being withdrawn from Dunkirk.

The occupancy of the present landlady, Caroline Cheffers-Heard, can be traced back to 1897 and her great-grandfather. William John Gibbings was from Clyst St George, when he took on the licence of the Bridge, which he ran until his death in 1930. He was a member of Topsham Parish Council, and on the committee of the Exeter Horticultural Society. During the 101st year of the Gibbings family involvement with the house, the Bridge Inn was honoured to be chosen for a visit by HRM Queen Elizabeth, when she 'popped in' during March 1998. The Queen was shown commemorative flags that were flown at her father's Coronation, before being presented with a case of '101' ale from the Branscombe Vale brewery. The present licensee promotes local ale with a fine selection available at the bar. Apart from the large bar at the back, there is a 'sitting room' at the front of the building with a cosy log fire in the winter. This is much like early inns and pubs in the country, with a little serving hatch in the passage to purchase your order. In addition, the Bridge has regular music evenings, when jazz, blues and folk concerts are given.

DRAKES

In 2014, the Co-op in Fore Street, Topsham, expanded into the old wine bar known as Drakes, and thus, another well-established and historic pub closed. The beginning of the hostelry was in a building dating from the seventeenth century, which became the home of the business of George Gale, a Topsham based wine and spirit merchant and maltster. He was listed in the trade directories of 1839 and 1844. His premises became the South West Hotel, the Western Union Hotel and sometime after the London and South Western Railway reached Topsham in 1861, the London and South Western. From around 1870, the hostelry was run by Charles Gale, George's son. Charles was married to Tryphena Sparks, who was a cousin and one-time close friend of Thomas Hardy, the novelist. They had been particularly close between 1868 and 1870, and they may have been engaged, although the evidence is inconclusive; the friendship was certainly romantic, although it rapidly cooled when Hardy met Emma Gifford in 1870. Hardy married Emma in 1874 and Tryphena married Gale in December 1877 at Plymouth.

By 1881, Charles and Tryphena had two children, two-year-old Eleanor, and one-year-old Charles, and other relations, servants and boarders living at the South Western Tavern. They had two more children, George and Herbert, by her death on

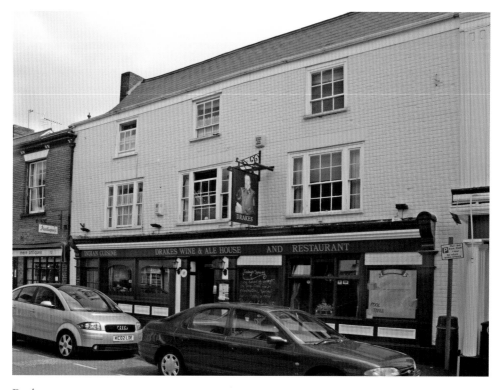

Drakes.

17 March 1890, from a rupture caused by childbirth. Tryphena was well known in Topsham for her work to improve the lot of local fishermen. At her funeral, her coffin was carried by fishermen to the graveside. Sometime after the funeral, Hardy cycled to Topsham with his brother Henry and visited the grave, where he left a note on the grave that read 'In loving memory – Tom Hardy'. He was not given a warm welcome when he called on Gale to pay his respects. It was in the same year that Hardy started writing *Jude the Obscure*, with the character Sue Bridehead, who may have been based on Tryphena Sparks.

After the tragedy, the licence of the hotel was transferred to William Moore, and soon after, the hotel was sold to the Finch Brewery and refurbished. After the Second World War, the upper floor of the premises was a hayloft to service the still-existing but unused stables at the rear. The pub hit the news a few years back when the *Sunday Sport* newspaper reported that the pub and all its clientele were transported into space; obviously they were lacing their drink with rocket fuel that night! It was not until 1994 that the name changed to Drakes, and food became an important part of the business. Heavitree Breweries closed Drakes in February 2013; the adjacent Co-op expanded into the premises, removing one of Topsham's old, established inns from Fore Street.

GLOBE HOTEL

Dating from before the first documented date of 1700, the Globe has been at the centre of life in Topsham for more than 300 years. When Topsham was a flourishing port in the mid-seventeenth century, a healthy trade in port wine from Portugal developed. The Globe was certainly involved in this trade as the 'Globe' was the sign of the Portuguese Wine Traders. From 1795, Richard Harrison ran the hostelry; he was also a member of Topsham's fledgeling fire service. He retired in 1824, passing on the business to his son, also known as Richard. His son, John Swale Harrison, was in charge after his father's death in 1843, and by 1861, John Patch Harrison. The Harrisons built the Georgian façade and retitled it as the Globe Hotel in 1851, influenced, no doubt, by the Royal Clarence Hotel in Exeter, the country's first hotel. In the 1830s it was a coaching inn, with coaches travelling to Lyme Regis, Salisbury and London starting their long journeys at the Globe. Horses were stabled in Globefields at the rear of the hotel, an area now filled with housing. The Globe, in common with many other hostelries, was the venue for many sales of land, dwelling houses and animals. However, being established in a shipbuilding town, it was often the venue for the sale of boats. In 1828, the hull of the bark, *Helena* was put up for sale at the Globe, as she lay in Davy's yard. Another interesting sale at the Globe was in 1836, when a rope yard and walk of around 140 fathoms in length was auctioned. The association of the Harrisons with the Globe ended in 1883, when John Patch's single surviving daughter did not want to continue running the hotel. John Widger Lee purchased the hotel, which was still thatched, along with the brewhouse, malt house, yards, stabling, gardens and paddock. On the first floor, a drawing room is said to have been a merchants' meeting room, while a Masonic Hall at the rear was used by the Brent Lodge of Freemasons, and could only be entered via a narrow lane; in 1906, the hotel gained permission to make a door for easier access from the main building.

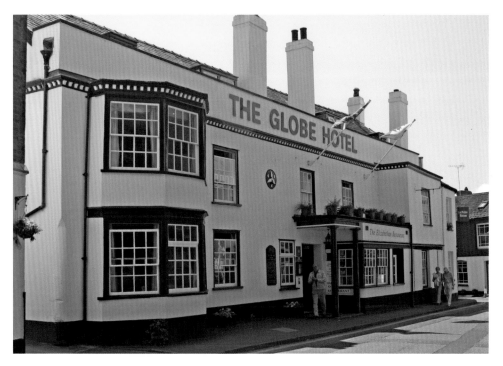

The Globe Hotel, Topsham.

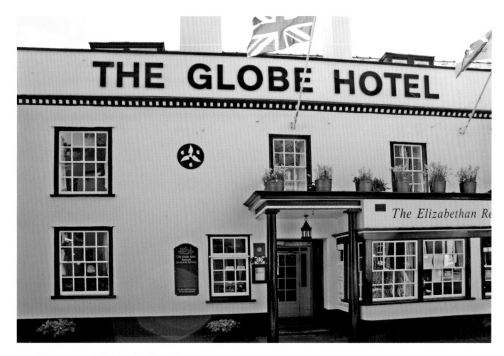

The frontage of the Globe Hotel.

The Last Hundred Years

From before the First World War until 1923, John William Radford ran the Globe. He was said to refuse to serve patrons if he didn't agree with their political views. On the front wall can be found a black disc with three spoke like wings, and the letters 'CTC'; this is an Edwardian sign for the Cyclists' Touring Club, showing that the hotel welcomed cyclists. In 1978, Denys Price took over the licence of the Globe, and added a six-room extension in 1986. He was succeeded by his wife and daughter, Ann Price and Liz Hodges, who are still running the hotel more than thirty years on. One of their innovations was inviting the fledgeling Topsham Ales Community Brewery to locate in premises at the rear of the hotel. They brew beer that is sold in the Globe, Exeter Inn and the Bridge. The brewery produces River, Mild Winter and the Mythe, with part of their profit going to social causes in Topsham.

LIGHTER INN

This inn takes its name from the *Lighter*, a flat bottomed boat used at Topsham to unload larger ships that anchored in the middle of the channel. From 1760, it was a harbour master and custom house. The present building was largely rebuilt after a fire in 1971, as a facsimile of the original, which was an amalgam of two buildings. The first sale notice for the *Lighter* appeared in the *Flying Post* in August 1828, as one of three lots for auction at the King John Tavern, Exeter:

> Lot 2. That old, well-established, and desirable PUBLIC HOUSE, situate on the Quay at Topsham, called the LIGHTER, now in possession of Sarah Ireland.

The inn was not sold, for it was for auction again with Ireland in residence in April 1829. By February 1832, Mrs Perriam was in residence, and fined a shilling for allowing tippling, on the premises, according to the *Devonshire Chronicle & Exeter News*. In the previous issue, it was reported that a row involved five men who had been fined a total of 16*s* for assaulting a Mr Jones on the Quay, after their so-called tippling.

In 1861, a railway siding from the station was cut down to the quay, terminating right next to the *Lighter*. The quay became a fenced, commercial area, where vessels unloaded salt cod, herring and guano to be shipped out by rail. The drinking clientele for the Lighter were predominantly seamen, fishermen, stevedores and railwaymen. London and South Western Railway stored railway sleepers on the quayside, before they were treated with creosote and transported out for use. This led to the pollution of the Lighter Inn's well in 1876; creosote was also responsible for a similar incident at the nearby Steam Packet two years later.

The Lighter Inn belonged to the St Thomas Council, who agreed to lease it to the St Thomas brewery of Stevens and Pidsley in 1884. They set to work to rebuild the house in 1886, possibly prompted by a fire the same year that damaged the stables, cellar and kitchen. Three years later, they applied and were granted permission to extend the bar and add a brewhouse at a cost of £50. For several years, from about 1895, the landlord was William Voysey, who was also engaged in the ownership of cargo vessels that ran

The Lighter Inn is on Topsham's quay. In the 1890s it was popular with salmon fishermen.

The Lighter Inn today.

The lounge at the Lighter Inn.

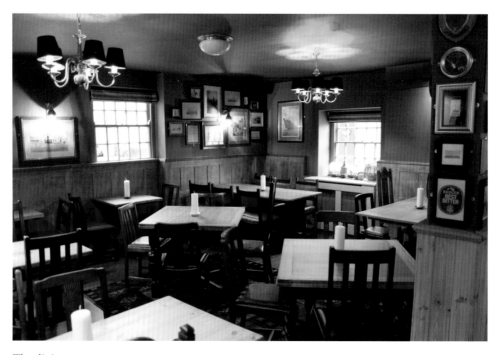

The dining area.

A warm welcome at the Lighter Inn.

out of Topsham. One ketch, the Tommy Dodd, was badly damaged by fire in 1900, while a dispute arose in 1904 when the captain refused to take another of Voysey's vessels to sea, laden with bricks, as he considered it to be overloaded. Voysey died in 1909 and the licence transferred to his son, William Bannen Voysey. In 1914, Mr Eli Pring, formerly of the Exeter Inn, took on the licence, thus ending the Voysey's interest in the house.

The rail siding to the quay was closed in 1958 and, despite the Tuborg larger warehouse remaining on the quayside for a few more years, the area opened to a growing tourist trade; the warehouse is now a flourishing antiques centre that is often featured on *Bargain Hunt*. The King's Beam in front of the house is a relic of the age when goods were weighed by the customs authorities.

Gutted by Fire

On 4 May 1971, the inn was gutted by fire. The headline in the *Express & Echo* was '10 Escape as Blaze Sweeps Exeter Inn'. The article went on to say, 'The fire started at dawn and swiftly spread to the roof timbers of the historic building one of the oldest in Topsham Smoke from the fire could be seen at a distance and roof tiles burst and scattered...' Now, the inn is owned by Hall and Woodhouse of Dorset. The house remains popular in the summer months with the many tourists who visit Topsham and enjoy the view across the estuary to the Exminster Marshes from the tables on the quayside.

PASSAGE HOUSE INN

The Passage House Inn on Ferry Road in Topsham has become a favourite hostelry within
Topsham, where on a summer's evening, you can sit in the garden across the road and
watch the sun sink into Exminster Marshes. Situated facing the Exe estuary, the hostelry
started life as the ferryman's house. There is evidence from medieval times that there was
a ferry at this point, thus avoiding a long walk of at least four miles up to the Exe bridge
to cross the river and four miles back. Ferry Road was originally Lower Passage Way,
accounting for the present name of the house. The first hostelry on this site was named the
Ferry Inn, probably from the early 1700s; the owner had the rights to the passage across
the river to Exminster Marshes and beyond to Chudleigh. A deed dated 1736 refers to
a licence granted to Benjamin Buttall and John Wear for a passage across the river. The
House of Commons Journal of 1803 records a petition presented to the House by Samuel
Webber and Thomas Nosworthy, that they, as the proprietors of a ferry or passage across
the river should receive a certain Sum of Money if a proposed ford be allowed across the
river, that was closer than a mile and a half to their ferry. The integration of the ferry and
public house is demonstrated by this advert from the *Flying Post* in May 1823, when the
name Passage House Inn was used for the first time:

> To be LET All that old established and well-accustomed Public-House, known by
> THE PASSAGE HOUSE, With the FERRY BOAT thereto belonging, situate at
> TOPSHAM, near Passage Lane, now in the occupation of Mr Ireland .

A case of assault and battery was heard in 1866, when a labourer, William Ware, was
charged by the landlord, Albert Hall, with assault. Ware was stranded on the far bank,
after the ferry had ceased working for the day. When he eventually crossed to Topsham,

The Passage House Inn was once named the Ferry Inn.

the drunken Ware went to the Passage House and accused Hall's son of refusing to fetch him. Hall ordered Ware to leave, when his son was struck with a blow. The house was also patronised by local fishermen, who would land their catch early. Henry Dally, the landlord in 1873, applied to open two hours early at 6 a.m., to cater for their needs. Landlord John Bolt started as the ferryman in 1897, eventually becoming the landlord. He received the worst news of all when his son William died of his wounds in Italy in 1918. How many families in Topsham received such news during the Great War, one wonders? Bolt was to bury a second son the next year, although the reason for his death was not reported. The licence passed to a third son, Robert, and from Robert after his death to his son Benjamin in 1937.

Around about this time, the Passage House had been purchased by the Heavitree Brewery, and was extended to incorporate an adjacent Dutch style building. The licensed trade obviously was not to Benjamin Bolt's taste, for in January 1939, the new landlord's wife, Mrs Davis, escaped death when a 33-foot stone wall at the rear of the premises collapsed, just as she had crossed the yard. The collapse was thought to be caused by a recent frost followed by heavy rain. It is estimated that 150 tons of stone and earth fell across the yard, partly demolishing a wall of the public house, rendering a door to matchwood, and demolishing a washhouse; a batch of clothes ready for washing and a mangle were buried beneath the rubble, while lavatories and other outbuildings were destroyed. A brick vault under the collapsed wall survived, prompting Mr Davis to remark that it would make an excellent air raid shelter. The vault, built of Dutch bricks, could shelter thirty people in an emergency. It was thought to have once been a beer store or brewhouse.

The Building

The left section of the modern Passage House Inn is a seventeenth-century gabled three-storey structure, while the main, right-hand section is set back. There is a Tuscan doorway with fluted pilasters surmounted with a simple pediment. A lead tablet is inscribed 'T N Pake 1788'. The modern Passage House Inn has a restaurant for twenty and a bistro area, as well as serving barbeques in the garden overlooking the river. The manager runs a quiz night on Tuesdays, ensuring there is something to attract both locals and visitors alike, and you can still use the ferry from Exminster to have a drink.

ROUTE ONE, TOPSHAM QUAY

Formerly the Steam Packet

Situated just behind the Lighter Inn, the old Steam Packet had a rather attractive sign painted on the side wall, until 2008, of a nineteenth-century steam packet. It is thought to be Topsham's second oldest hostelry, originally named the Red Lion. Indeed, Amity Court, which lies behind the building, was once called Red Lion Court. At one time, the hostelry brewed its own beer and boasted two skittle alleys. It was renamed the Steam Packet after the steam-driven packets that sailed every Saturday from Topsham, for a three-day journey to London, calling at Cowes and Portsmouth, returning from London on the Wednesday. The fair was 10s on deck and a guinea in a cabin. The

first landlord of the Steam Packet was John Ellis, who ran the house in the 1840s. The proximity of the Steam Packet to the quay made it a popular drinking hole for lightermen, quay workers and fishermen. The newspapers list a disproportionate number of cases of drunkenness before the courts of fishermen; perhaps as they waited for tides and weather to fish, they spent their time drinking in the house.

Creosote in the Beer

In January 1878, the former landlord, Mr Henry Pearce, took the London and South Western Railway to court for allowing a well belonging to the Steam Packet to be polluted. Pearce had received complaints from customers about the taste of his beer soon after the LSWR had deposited a large number of barrels of creosote for treating railway sleepers next to his premises. It was alleged that the railway had allowed the creosote to leak and gather in pools on the ground. Water from the well was tested and found to contain tar, hence the claim for substantial damages for having to obtain pure water from another source. George Wannell, who had lived at Topsham all the days of his life, said the beer in the Steam Packet used to be the best in Topsham, but for the last eighteen or twenty months it had been 'mortal bad'. Further samples of water were found to contain sewage while other samples were clean. The LSWR won the verdict and costs were awarded to them.

During 1883, the house was empty for several months. When an application for a new licence was made, the deputy chief constable objected, siting allegations against the house. It was argued that there were already sufficient public houses in Topsham. A counter claim was made that the Steam Packet was one of the oldest houses in the town, and as such, the licence for one of the newer houses should be revoked. The licensing committee considered the application before granting it. A few years later, the owner but not innkeeper of the Steam Packet was Charlie Gale, who ran the London and South Western, now Drakes. His wife, Tryphena Sparks, was a cousin and one-time close friend of Thomas Hardy.

A grisly murder in Coombe Street, Exeter, in August 1895 led to the arrest of the murderer in the Steam Packet. On the evening of the 28 August, a stranger entered the bar and after a short conversation with another customer was offered 'three ha-porths'. The stranger remarked, 'You won't pay for many more three ha'porths for me, that is very certain'. About two hours later, while the stranger was out the back, another customer entered and asked if anyone had heard of the murder in Exeter that morning. The stranger returned and John Bagwell, the landlord, asked him if his name was Harris. 'Yes', he replied. 'You are not the man who committed the murder, are you?' He jumped up, and replied, 'Yes, I am the man.' I said, 'Nonsense; you are not the man,' and he repeated, 'I am. I will go to the Police-station and give myself up.' Bagwell left and fetched Sergeant Gerry, who said to the stranger, 'Is your name Harris?' and he said, 'Yes.' I then charged the prisoner, on suspicion, with murdering the woman named Harris at Coombe-street the previous night.' Harris was found guilty and sentenced to death, only to be reprieved a few weeks later.

The Steam Packet was closed by its owner, the Heavitree Brewery, on the weekend of the 8 November 2008 when the landlord, Barry Stock, retired. The house was then

The Steam Packet in 1956.

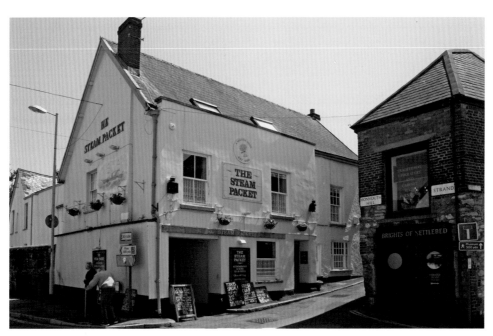

The Steam Packet around 2005, which has since closed and become Route One, a café bar offering bicycle hire.

purchased for £500,000 by the owners of the Globe Hotel from Heavitree Breweries, who had owned it for the previous hundred years. It was refurbished at a cost of £100,000 for re-opening as a licensed 'surf' café bar with bicycle hire and repairs.

SALUTATION INN

The Building
The Salutation Inn presents a frontage on Fore Street that has barely changed since 1720, when it first opened as a coaching inn. The main façade is of white stucco, three storeys high, with four sash windows per floor. On the left is a protruding wing, supported by two brick columns (originally timber Doric columns) that project over the pavement. Over this is a fine Venetian style window for what was the Assembly Room, and later a billiard room. Beneath, at street level there are panelled gates through which packhorses and coaches entered the rear yard. The hotel has twenty-six rooms spread across the three floors.

History
In the time when Topsham was an important port, there was a need for accommodation for merchants and travellers. The Salutation Inn opened in 1720 as a coaching inn, on what some sources suggest was previously the site of a granary. In 1768, the inn was rebuilt by Mr Baker, who had become wealthy after a poor childhood. For a short time in 1794, when England was expecting a Napoleon-led French invasion, the inn was the headquarters for Colonel Robert Hall's Devon and Cornwall Fencibles. They were raised to patrol the coast and protect the citizens from any incursion.

Topsham Comes Out Against Slavery
Just two years before the Devon and Cornwall Fencibles occupied the Salutation, the *Flying Post* reported a meeting of the inhabitants of Topsham at the inn, when almost unanimously, they agreed to sign a 'Petition to Parliament for the Abolition of the AFRICAN SLAVE TRADE'. The petition went on to say,

> That your Petitioners cannot know that very considerable Numbers of their Fellow Creatures are trepanned or forced from their native Country and tenderest Connections, and subjected to a capricious, rigorous, and involuntary Servitude, without feeling a Conviction that the Exercise of the African Slave Trade is injurious to the natural and inherent Rights and Privileges of Mankind. (6 March 1792)

Throughout the nineteenth century, the Salutation Inn was a centre for balls, public meetings, property auctions, society dinners, coroner's inquests, and as an unofficial mortuary for people found drowned in the Exe. As an important public venue, many political meetings and dinners were held there to celebrate the election of the local Member of Parliament. The first Freemasons Lodge in Topsham was formed at the Salutation in 1764, and it was still used for Freemasons' banquets as late as 1927.

In 1846, the first annual sheep shearing match was held on the bowling green, at the

rear. Each of nine competitors brought three sheep to the event. The sheep were placed in a circular pen, in the middle of the bowling green, and just after eleven started the contest. Within two hours, all the sheep had been sheared. The *Western Times* reported, 'The animals, all bleating and astonished at their new nakedness, were driven under the flag staff, and inspected by the judges.' The Topsham Band played several popular melodies during the contest. What the event did for the surface of the bowling green has to be imagined.

Wrestling Matches

Topsham's annual wrestling matches were held on the bowling green, a space that existed from at least 1687, until its last use in 1917. Wrestling was a serious and tough version of the sport that attracted large crowds. One wrestler, Abraham Cann who came from Colebrooke, near Crediton, was a great favourite with the betting clientele. He is believed to have been the champion of England in 1827. Although Cann often fought for a £500 purse, he also ran the Champion Arms in Bartholomew Street. Cann appeared with his brother at Topsham as early as 1822, and was a favourite with the crowds. The last wrestling match at the Salutation appears to have been as late as 1876.

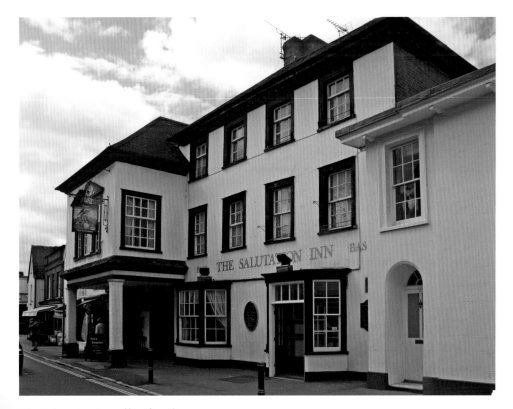

The Salutation Inn offers fine dining.

After the Second World War, the Salutation did not fair so well, as competition from foreign holidays prevailed. By the turn of this century, the pub, for that was what it had become, was decidedly scruffy and struggling until it closed in 2009. In 2010, it was purchased by local Ed Williams-Hawkes, whose family had previously owned the Imperial Hotel in Exeter, with a view to turning it into a boutique hotel with a restaurant and café. In November 2012, the revamped hotel opened its doors for the first time, serving fine food throughout the day, and offering exclusive accommodation.